Growing Up in —
SAN FRANCISCO'S
CHINATOWN

BOOMER MEMORIES FROM NOODLE ROLLS TO APPLE PIE

EDMUND S. WONG

THE
History
PRESS

Published by The History Press
Charleston, SC
www.historypress.net

Copyright © 2018 by Edmund S. Wong
All rights reserved

Front cover, top left: photo by author; *top center*: author's collection; *top right*: photo by author; *bottom*:
the Eastern Bakery, where Chinatown residents and visitors still go for their favorite Chinese
or American treats. The Republic Hotel sign is a reminder that crowded and drab single-
occupancy rooms are still home for many who live in Chinatown. Photo by author.
Back cover, top left: photo by author; *top right*: courtesy of Cooper Chow; *bottom*: author's collection.

First published 2018

Manufactured in the United States

ISBN 9781467139359

Library of Congress Control Number: 2017958369

Notice: The information in this book is true and complete to the best of our knowledge. It is
offered without guarantee on the part of the author or The History Press. The author and
The History Press disclaim all liability in connection with the use of this book.

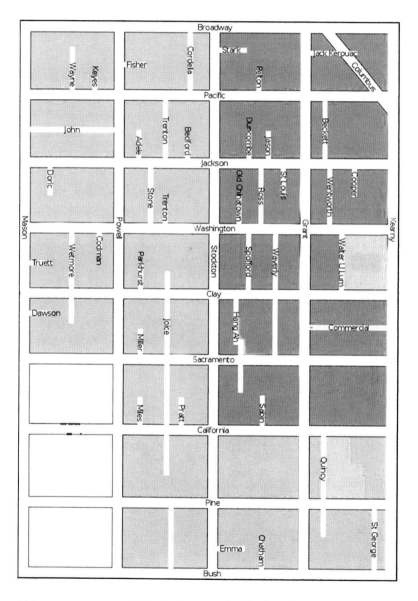

Chinatown street map. *Wikimedia Commons; altered by the author.*

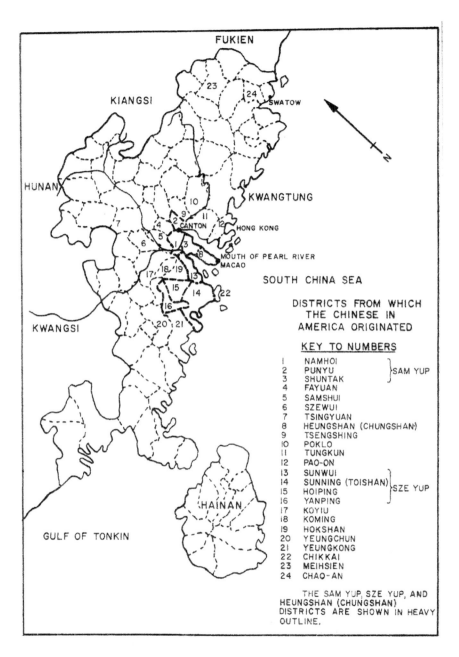

FUKIEN

KIANGSI

HUNAN

KWANGTUNG

SWATOW

CANTON

HONG KONG

MOUTH OF PEARL RIVER

MACAO

SOUTH CHINA SEA

KWANGSI

DISTRICTS FROM WHICH
THE CHINESE IN
AMERICA ORIGINATED

KEY TO NUMBERS

1	NAMHOI	
2	PUNYU	} SAM YUP
3	SHUNTAK	
4	FAYUAN	
5	SAMSHUI	
6	SZEWUI	
7	TSINGYUAN	
8	HEUNGSHAN (CHUNGSHAN)	
9	TSENGSHING	
10	POKLO	
11	TUNGKUN	
12	PAO-ON	
13	SUNWUI	
14	SUNNING (TOISHAN)	} SZE YUP
15	HOIPING	
16	YANPING	
17	KOYIU	
18	KOMING	
19	HOKSHAN	
20	YEUNGCHUN	
21	YEUNGKONG	
22	CHIKKAI	
23	MEIHSIEN	
24	CHAO-AN	

THE SAM YUP, SZE YUP, AND
HEUNGSHAN (CHUNGSHAN)
DISTRICTS ARE SHOWN IN HEAVY
OUTLINE.

HAINAN

GULF OF TONKIN

Map from Thomas W. Chinn, ed., *A History of the Chinese in California*, 1969.

CONTENTS

PREFACE

Growing Up in San Francisco's Chinatown is a collection of firsthand memories, stories and anecdotes contributed by some of the city's Chinatown-raised baby boomers who were born in the late 1940s or early 1950s. Among them are American-born Chinese, or ABCs, and those who arrived in San Francisco as very young children from Hong Kong or other parts of China. Practically all of them are descendants of the Toishan region in southern China. Until the mid-1960s, Toishan was the area from which practically all Chinese landing on American shores originated. Their native language, Toishanese, consists of several variants that are much closer to Cantonese than to Mandarin. While none of those who are featured in this book can be considered famous or even well known, all have had good and productive lives. They have done well by their loved ones. Today, most of them are retired; many are now grandparents.

All of the former Chinatown kids who contributed to this book hope that their stories will stand the test of time and serve as a legacy that future generations of ABCs can appreciate. The Chinatown kids additionally hope that more than a few of the countless tourists once charmed by their San Francisco landmark neighborhood will read their stories. Such readers will surely enjoy discovering "hidden" and "behind the scenes" accounts of the Chinatown that they may have imagined but never actually got to see. Another set of readers who will find Chinatown kids interesting are the many millions who live in China and other places with large Chinese communities overseas: Taiwan, Singapore and Malaysia, among others.

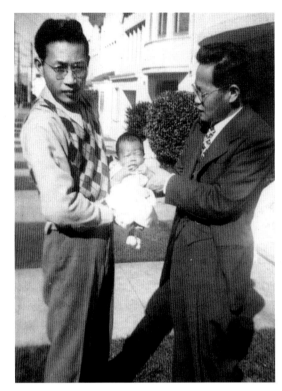

Left: A first-generation ABC and heir to the family name, 1948. *Author's collection.*

Below: An elder brother's map drawn from memory as a guide for his sisters on their journey to find the family's ancestral village. *Courtesy of Laura Wong.*

✝ = watch towers at each end of the village

the fish pond lies between the houses and the fields

A sign on the number 55 bus going through Chinatown hopes the past will not become the future. *Photo by author.*

Those ABC boomers who have visited China know firsthand just how deeply the curiosity about their overseas brethren runs for the Chinese.

The issue of immigration has once again become a broad national concern, with unwelcoming attitudes and government proposals to limit or exclude certain groups from entry into the country. The exclusion laws aimed specifically at the Chinese from the 1880s until 1943 have never been far from the minds of this book's Chinatown kids. That history adds to their strong wish for their stories to reach far beyond their onetime Chinatown home. They want to touch as many of those around the world as possible whose own lives were also forged by the challenges inherent in the immigrant experience.

AUTHOR'S NOTES

*T*he core content of *Growing Up in San Francisco's Chinatown* was provided by more than fifty former residents of the neighborhood. About a dozen of these individuals communicated directly and at length with me through face-to-face interviews, phone conversations and/or email exchanges. Their words, directly quoted and, at times, paraphrased, supply the stories that fill this book's nine chapters. Other contributors offered their thoughts and ideas through brief conversations, written communication about a page or less in length or social media posts, some of which were initiated by me. Among these posts were two that asked, "What were some of your favorite and least favorite foods while growing up?" and "Did you ever work for a business owned by your family?" Several other social media posts were initiated by others but capitalized on by me for further details. Some of these provided stories and anecdotes for the chapters "Showtime and Movie Nights" and "Expectations and Discipline." Traditional sources; notably books, archived films, news articles and web articles, fill out the rest of the book's chapters. Unless otherwise noted, quoted material comes from interviews I conducted.

Several contributors who wished to remain anonymous were assigned pseudonyms. The names of other persons mentioned or discussed within their narratives have also been changed. All of the information contained within their pages, however, is completely true.

Each of those whose voice is included in *Growing Up in San Francisco's Chinatown* has painted a broad picture of the neighborhood and their

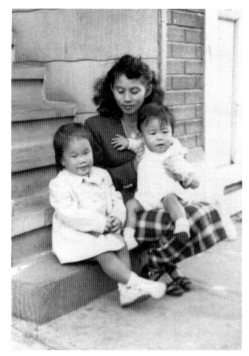 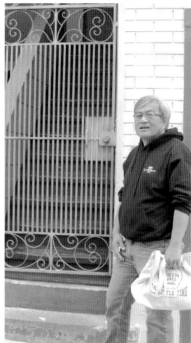

Left: The author, his mother and his cousin Sherry Lee on the steps of Sherry's John Street family home, 1949. *Author's collection*.

Right: The author visiting John Street in 2015. *Photo by author*.

activities within it as best they can recall. Faded or selective memories notwithstanding, any errors or misinterpretation of facts as told to me remain my full responsibility. Many socially and politically significant developments that continue to shape Chinatown and the lives of its residents moving forward took place in the neighborhood in the 1950s and '60s. As this is less a history book than it is a collective memoir, these matters are only included in this book through the words of those contributors who chose to mention them.

In addition to the individuals who took the time to contribute to this book, I wish to acknowledge Leland Wong of San Francisco for his most helpful Facebook page and forum, "We Grew Up in San Francisco Chinatown."

I wish to thank Schein and Schein for their generosity in allowing access to the images contained in the Ken Cathcart Collection of historical San Francisco Chinatown photographs. The entire collection and more can be viewed at Scheinandschein.com.

Author's Notes

Charlie Wambeke and Melody Chan Doss-Wambeke merit a nod of gratitude for their early-morning foray into Chinatown on a specially requested photographic mission.

I especially wish to thank my wife, Elizabeth Rouse Wong, and daughter Allison Wong Hooker for their love and support. These have been joyfully received not only during the writing of this book but at all times and in all places.

—Ed Wong, 2017

INTRODUCTION

*F*rom the mid-nineteenth century until the latter stages of World War II, the forbearers of those who would grow up in San Francisco's Chinatown as baby boomers sailed for what they hoped would be fairer shores. They abandoned underdeveloped villages in southern China that perpetually experienced famine, natural disaster, incompetent or corrupt governance and war. They embarked on arduous voyages for a land governed by immigration laws specifically directed against the Chinese. As women and children were strictly forbidden from entry, married men abandoned their families, and bachelors expected to remain single. Still, they called their ultimate destination *Gum San*, the "Golden Mountain." Despite the optimistic nature of that name, the men from China's Toishan district were not so naive as to think that their first steps ashore would yield immediate wealth or the end of hardship. Despite their small physical stature, they came fortified with outsized resolve and determination. They were prepared to endure continued and even greater hardships than those they had known at home. They aspired to replace suffering that never yielded rewards with struggles that could at least provide hope. Their own lot might not improve, but they were prepared to give their all for those left behind or for whoever might come in the future.

The stories in this book look back to the days of its contributors' childhood and adolescence. It was a time when parents and grandparents held them close to the culture and heritage of old China. The youngsters, however, also felt the strong pull of a future sheathed in the red, white and blue of America.

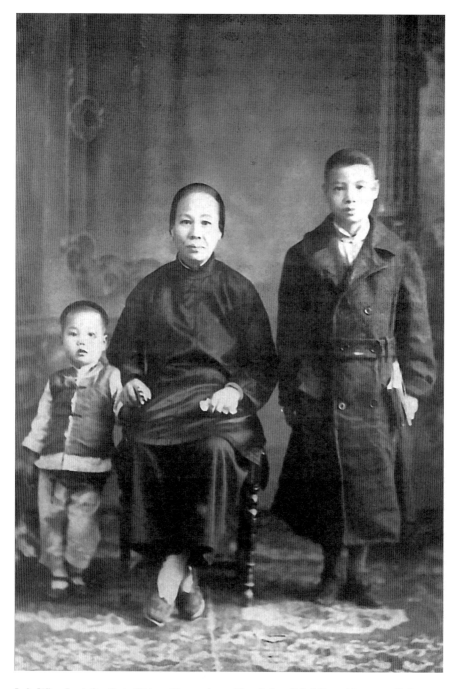

Judy Wing Lee's family in China. Her uncle and her father (*left*) followed her grandfather to Ohio. Her grandmother remained behind. *Courtesy of Judy Wing Lee.*

The author's paternal grandfather poses with his parents on their wedding day in San Francisco, 1947. *Author's collection.*

Many of San Francisco's American-born Chinese (ABCs) of the baby boomer era lived within the confines of the twenty-nine-square-block section of the city that was Chinatown. The neighborhood, characterized as a city within a city, provided its residents with everything they could need or want: homes, shops, schools, restaurants, entertainment venues, medical services and employment. Centrally located Chinese Hospital is where many of the ABCs were born. Their grandparents and parents who had settled in Chinatown upon first arriving from China had originally been denied access to the rest of the city. The immediate postwar years saw the city become a bit more welcoming to its Chinese citizens, and Chinatown began to grow and push its way toward North Beach and Telegraph Hill.

All of Chinatown—from its many, many alleys to the block-long sprawl of any of its four Ping Yuen housing complexes—was an extension of the ABCs' individual homes. They knew every nook and cranny, and they knew most of the people in the streets, the shops or residential buildings. If the American-born generation did not know them, the Chinatown old-timers certainly knew the youngsters. The elders also knew their parents. More often than not, they knew the kids' entire extended family. They kept an eye on the kids wherever they went and whatever they did. They guided, chided and kept them safe. So long as they behaved and were respectful of others, they could go anywhere and do anything from early in the morning until late at night.

Through their memories, these ABCs show readers how they spoke two languages, bought into two nationalities and reaped the benefits of two rich and vibrant cultures. Sometimes the two cultures were so blended that they could not distinguish one from the other. Some residents continue to grapple with the matter of identity—Chinese, American or both? One former

Chinatown kid remembers enjoying *foo-yue* sandwiches as much as he did peanut-butter ones. Foo-yue is a Chinese condiment made from salted and fermented bean cake. Like peanut butter, it comes in jars and can be easily scooped out and spread on a slice of bread. The liquid medium in which foo-yue sits offers a bit more than peanut butter does, however—it could provide a hint of an alcoholic buzz or could make you sick.

This book's anecdotes will take readers deep into Chinatown to illustrate how the ABCs and their parents shared the neighborhood and their lives with tourists. They served them in shops and restaurants. They gave them directions to all the "must see" spots in the city. They answered questions about themselves or about China. What they sometimes told the visitors was a blend of truth and fiction. They inherently knew that "I don't know" in their very own part of the city where they earned their livelihood through the tourist trade was not good for business. After the day's last visitor had left, the people of Chinatown could return to their own lives at home.

The ABCs beckon readers into their homes. For many, it was a small living space in back of or on the floor above a family business. Chinatown's housing, then as now, included small and cramped apartments or flats. Some residents lived in one of the four high-demand housing projects on Pacific Avenue, the Ping Yuen ("Peace Gardens"). Others shared a single room with a communal kitchen and bathrooms down the hall with far too many neighbors. Their laundry, hung to dry from rooftops, balconies and fire escapes, provided a little color to dank buildings crowded against one another in narrow alleys. There were often multiple generations of relatives living with the young ABCs. Knowing nothing different, few were unhappy about their living conditions. Few realized that Chinatown was in reality a ghetto.

Readers walk beside adult ABCs as they once more stroll down well-worn streets, such as Grant Avenue, Stockton Street, Clay Street, Jackson Street, Beckett Alley and Waverly Place. They stop at their old markets, movie houses, late-night snack, or *siu-yeh*, joints and the *gai-chongs*, where so many of their mothers labored as low-wage garment workers. They walk by the old shops and businesses where they worked for their families, the playgrounds where they so quickly adapted to all-American games and the various Chinese schools they were usually loath to attend.

All of the one-time Chinatown kids who have contributed to this tour of remembrances hope that all who would join them will see and know the deepest corners of San Francisco Chinatown's heart and soul as they were in its golden age.

DUAL CULTURES AND IDENTITY

"I WAS TOTALLY CONFUSED"

*B*y the late 1950s and early '60s, many postwar ABCs were reaching their teen years. Approaching or already in junior high or high school, their cultural orientation and national identification had gravitated strongly toward those of mainstream America. A great number of these ABCs had already begun to lose fluency in their parents' and grandparents' native Chinese. Outside of school, the media—radio, television, cinema, popular magazines and daily newspapers—pushed them even further away from the "old country" and its ways and into the broad embrace of the United States. There were fun and innocent things associated with America: Mickey Mouse, sock hops, hula hoops and rock 'n' roll. There were also darker things: teen angst, identity crises and racial ambiguity. For no small number of the ABCs, the matters of race and identity that first entered their consciousness during childhood remained to be figured out into their college and post-college years and beyond.

Still a Bit Different

"Our Physical Appearance Could Not Be Hidden or Denied"

A former Chinatown kid, now well over sixty years old and retired, looked back at who he was and what he thought he might one day become.

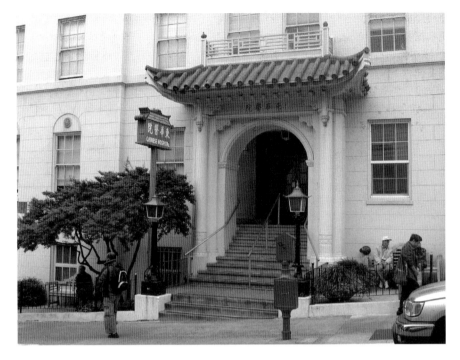

Former entrance to the Chinese Hospital, where many Chinatown kids were born. The entrance was removed when the hospital was remodeled. *Photo by author.*

My father came over from China when he was eighteen years old. My mother, however, was an ABC. Except for my paternal grandparents, there was nobody from my father's side of the family to have much influence on me. Of the people I grew up with in and around Chinatown, some, like me, had one ABC parent and one born in China. Others had both parents being ABC, and there were still others whose mother and father were both born in China.

I mention this because I think that having an ABC parent made me feel a little more American and less Chinese than some of my friends and schoolmates might have. We never talked about it that I can remember, but I always thought that I could tell which of the people my age that I knew tended to be "more Chinese" or "more American." I very strongly identified with the most typical American childhood heroes of television and the comics: Roy Rogers, Superman, Hopalong Cassidy, Dick Tracy and others. None were Chinese, of course. I didn't think too deeply about it as a child, but I innately sensed that they and I were different and that maybe I wouldn't grow up to be a detective or a cowboy.

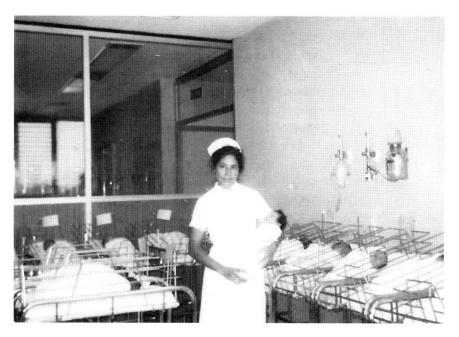

Baby boom! Nurse with a baby in the Chinese Hospital nursery, October 1949. Eight other newborns are visible. *Author's collection.*

Television shows had some Chinese characters, but I never cared for any of them. There was a butler character on the situation comedy Bachelor Father *and a cook on the Western drama* Bonanza. *A Walt Disney series that I liked about teenaged pals Spin and Marty at summer camp also had a Chinese cook. My paternal grandfather was a cook and butler (houseboy), and my maternal grandfather was a cook as well. I never saw them in the same way that I saw the characters on television. I hated the TV guys. I was embarrassed by them. They were portrayed as silly at best and outright stupid at worst.*

I remember one day when I was listening to a Giants baseball game on the radio, and I was just sitting by the radio while tossing a baseball up and down. My father walked by and said, "Ah! There he is! The Chinese Willie Mays!" I was flattered that my dad would acknowledge me like that, but I knew very well that there were no Chinese major-league players. Playing ball with friends at the North Beach Playground, we would sometimes announce to each other, "I'm Mickey Mantle!" or "I'm Stan Musial!" It was what we felt and even what we believed, but our physical

appearance could not be hidden or denied. Major-league baseball and a lot of other things probably weren't going to be for any of us. For my part, I suppressed that reality, but I still rarely deviated from feeling more American than Chinese.

Irene Dea Collier did not speak any English when she was brought to San Francisco by her parents at the age of five. She learned quickly, however, and she was soon often taken for ABC by her friends and schoolmates. She remembered a part of the quintessential rite of passage of becoming a teenager: "We had in the 1950s Chinese American teenagers becoming just American teenagers. In Chinatown we had Topps Fountain, we had the Chinese owned and operated soda fountain Fong-Fong. We had kids running around in purple jackets and slicked-back hair looking like Elvis Presley."[1]

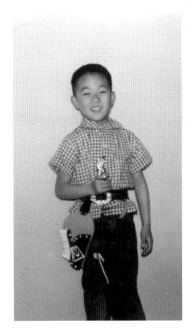

Inspired by his Wild West heroes, a seven-year-old cowboy brandishes his trusty six-shooter. *Author's collection.*

THE CULTURAL DIVIDE

"We're Chinese and You're Chinese-American"

Shawn Wong was born of immigrant parents in the United States. The family lived in Berkeley, and Shawn was familiar with San Francisco's Chinatown of the 1950s and '60s. Because Shawn's father worked for the U.S. military, the family frequently had to move from base to base both within the United States and abroad. Shawn's schoolmates and friends often were other dependents of civilians contracted to the armed forces or the children of military personnel. Few of these other children were Chinese. Shawn said:

My mother used to tell me, "We're Chinese and you're Chinese-American." I had no idea what that was. I didn't know what the difference was. My

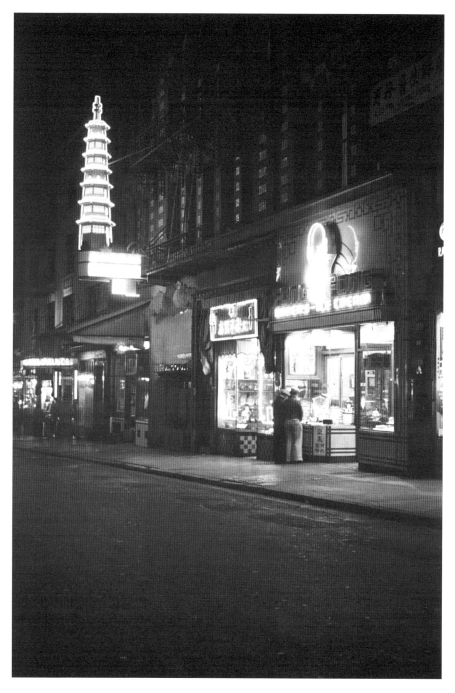

Fong-Fong (1935–1974) offered burgers, hotdogs, Cokes and ice cream, which included "Chinese" flavors such as ginger and lychee. *Ken Cathcart Collection. Courtesy of Schein and Schein.*

mother would wear Chinese dresses—cheung-sam. *My mother and father would speak Chinese to each other at home and, here I am, this little boy who wanted to be Willie Mays. I wanted to be Roy Rogers, "The King of the Cowboys." I didn't think of myself as being Chinese; I thought of myself as being just like any other American kid. I think I just had to figure it out on my own. Your parents are always telling you, "Be proud you're Chinese," you know and, of course, yeah, yeah, right, Mom! That doesn't help me out in the schoolyard.*[2]

GROWING AWARENESS

"It Was Racial, Right?"

As Chinatown's kids became old enough to understand movies, those films that were to make the deepest impressions on them were the ones aimed at the teenaged audience. One such film was *West Side Story*. Based on an original Broadway production from 1957, the film version came out in 1961. It was a national success and won ten Academy Awards. It was as wildly popular in San Francisco Chinatown as it was anywhere else in the United States. The story was an adaptation of Shakespeare's *Romeo and Juliet* set in modern times. The plot featured ethnically divided teen groups, young love and racial tensions, represented by a rivalry between the groups and a star-crossed attempt at interracial romance.

The themes and the more serious undercurrents represented by the film were not lost on its young Chinese American viewers. Brad Lum of San Francisco's Chinatown said: "It [the movie] was racial, right? Puerto Rican against White. It was kind of what we had to relate with. It was the 'Sharks' against the 'Jets.'"[3]

Reverend Norman Fong remembered going to see *West Side Story* a total of six times:

We always walked out of there snapping our fingers [as the actors had done in one of the film's featured dance sequences] *thinking that we're tough and "we bad." The sixties was turmoil everywhere in the world, but for us Chinatown kids it was life shattering. We had to go* [to schools outside of Chinatown] *and we faced racism for the first time. Growing up in Chinatown everyone's Chinese;*

everyone knows each other and then all of a sudden we realized that other people did not like the Chinese. I'm proud to be Chinese; I'm not embarrassed; I'm not ashamed. Maybe my parents' generation had to be, they were beat on too much. But for me; I'm born here, the next generation; I'm not gonna take it. After West Side Story *and all those movies, everybody learned. Sometimes you have to organize and fight back, then they leave you alone.*[4]

Norman described a personal experience linked to his fervent notions about "not just taking it" and "organizing and fighting back." One day, while just a grade-school student, Norman felt that his teacher was labeling or belittling the Chinese, and he chose to speak out.

I went to Jean Parker [for grade school] *where all the kids are Chinese but the principal and the teachers were all white. For me it was a time of racism. I got in trouble in the fifth grade. The teacher was making fun of the Chinese and I said, "Shut up!" to the teacher. So in the fifth grade I got expelled from school because I told the teacher to shut up. She was saying that the Chinese were good cooks and laundry people. Now, my dad was a cook, by the way, but I felt there was a little bit of a misunderstanding about why the Chinese ended up in those areas. So I said, "Shut up!" My mom was head of the PTA so it was very embarrassing. I felt that racism was a key issue in the 50s and the 60s. The Chinese community was not really that well respected.*[5]

Years later, Norman would be able to smile about this incident as he witnessed the student outcry and strike at San Francisco State College for substantive and more truthful representation of the Chinese and other minority races in higher education.

BILINGUALISM AT ITS CHILDISH WORST

Mrs. Horse Shit

Despite their youth and the sheltered community in which they lived, Chinatown's kids harbored a few of their own cultural insensitivities toward the adults who ran the schools they attended.

Although practically all Chinatown kids grew up fully bilingual in Toishan Chinese and English, many were quick to lose their Chinese language skills once they began to attend school. Some originally spoke only Chinese at home, while others used both languages. In a home where the family could speak either English or Chinese, it was not unusual to hear words from both languages intermingled within a single sentence, such as "*Nay tai* movie, *sic mut* snacks, *ah?*" for "What snacks did you have (earlier) at the movies?" When among friends and classmates, the youngsters' preferred language was always English. With each passing year, the ABCs' Chinese skills would become increasingly diminished. Still, the language, however little or however imperfectly retained, was something that would never fully disappear. One Chinatown ABC remembers some dual-language fun from his days at Washington Irving School in the 1950s.

The average kid knows practically all the swear words he is ever going to use as an adult by the time he starts school. Bilingual kids have the advantage of knowing duplicate sets of such vocabulary. There is one word that may or may not actually be a "bad" word in Chinese, although it certainly is

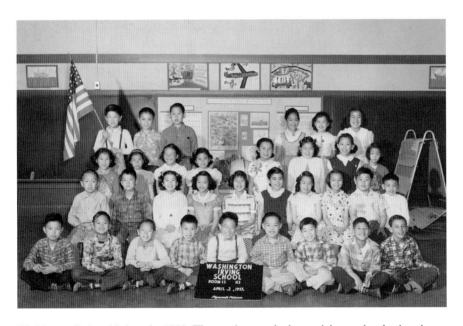

Washington Irving third grade, 1957. The two boys at the lower right are the class's only non-Chinese students. *Author's collection.*

in English. *The Toishan version of it roughly bears the tone of the western musical note of E or "mi" of "do re mi" and is pronounced "see." "See" spoken as the note E in Toishan Chinese means "shit." It was the context of using "see" in a conversation that determined if it was acceptable or not. If talking matter-of-factly about having or not having gone to the bathroom, it was alright. It was also proper to report that while visiting the zoo, one had seen a monkey sitting in a pile of it. It was perfectly fine and even a little bit funny to say something like, "The baby's diaper was full of it and, boy, did it smell awful." It would be a far different and impolite matter, however, to suggest that someone should go and eat some of it.*

At Washington Irving, my K–6 school, we American-born Chinese very much enjoyed wordplay with "see." There was a teacher of Italian descent named Mrs. Lagomarsino who had no real faults except, unknown to any Italians, her name. And this was only in the minds of young Chinese American school kids. We would call her "Lago-MA-SEE-no" when she was out of sight with great stress on the middle two syllables. "Ma," in a certain tone not duplicated by the musical scale, is a horse. So, behind her back, she was "Mrs. Horse Shit." Then there was the principal, a fearsome man of huge proportions to whose office we would never wish to be sent. His name was Mr. Orsini. We very privately referred to him as "Mr. OR-SEE-ni." With the "see" part clear, the "or" made it a verb, as in to make some or to take one.

Another Washington Irving teacher was Miss Fotinos. Her Greek name provided us with no opportunities to degrade it by blending it phonetically with Chinese. We would probably not have done so, anyhow. She was one of the school's kindest and most popular teachers. Still, that did not stop our clever little minds from having some good laughs at her expense.

One afternoon, during a geography lesson, Miss Fotinos was helping us locate and identify various bodies of water on a map. "Here, between Africa and the Middle East lies the Red Sea," she said, tapping the appropriate spot with a pointer. This was instantly and simultaneously translated by thirty little minds as "red shit." Thirty little voices exploded with laughter. "What's so funny?" asked our totally perplexed teacher. The fact that she had expressed puzzlement made it all the more hilarious to us. More laughter. "Come on!" she urged, "what's the big joke?" Seeing that our hilarity had not spoiled her overall tendency of being good-natured merely egged us on even further.

The laughter eventually stopped, but knowing a thing or two about geography, we sat on the edge of our seats and braced ourselves. "Well,

here in the Mediterranean," and she left it at that to our disappointment, "is Sicily, where the still-active volcano Mount Etna can be found." Miss Fotinos paused, let her eyes sweep the room and then visibly relaxed. "Now up here, further north," we got ready for it, "by Russia, is the Black Sea." If not from Etna, an eruption nonetheless ensued. "What's going on!?" Unabated hilarity. Tap, tap, tap! The pointer hit the nearby blackboard. "C'mon, tell me!" We stopped cold. Tell her? We looked at one another as if to ask, "Are you gonna tell her, cuz I'm not!" We sat still and tried to hide our smiles as we wiped tears from our eyes and bit our lips. We were feeling a little sorry for Miss Fotinos. "May I continue, please?" she asked. "Yes, Miss Fotinos," we contritely replied. It would not be for a few days before we worked our way across the Pacific to the Yellow Sea.

FURTHER MISADVENTURES FOR NORMAN FONG

"Let's Get the Chinaman!"

Two years after the incident at Jean Parker, Norman Fong was assigned to attend Francisco Junior High School, one of the places that he earlier described as a "school outside of Chinatown." Francisco was within walking distance of Chinatown, but being in North Beach, it was in the midst of a residential area populated by many Italian Americans. The following experience between Norman and a group of Catholic school students who were about the same age as him left its mark on the seventh-grade Chinese American boy.

While I was in junior high I got in trouble with the Italians who didn't like the Chinese. I got beat up. My first day going to Francisco Junior High, which is in North Beach, I remember walking across Washington Square [a public park directly across the street from Saint Peter and Paul Catholic Church and the Salesian Boy's School]. *I was a happy kid in Chinatown, right? The world is all Chinese then you gotta go to North Beach. I meet the Salesian boys as I'm walking by and they tied me to a fence and said, "Let's get the Chinaman!" So they water balloon tortured me…can you imagine those water bombs? Wham! Wham! Wham! And I got so angry. That was my first introduction to racism.*

There was a movement in North Beach: D.A.C. for Damn All Chinamen. "D.A.C." was spray-painted all over North Beach Playground. And I got beat up a few times by those boys just because I'm walking alone, which is not that smart.[6]

LOOKING TO FIT IN

American Enough or Chinese Enough?

Racial confrontations such as those described by Norman and even more severe ones were not the only source of emotional (or physical) growing pains with which Chinatown kids had to wrestle. There was also the confusion that often led to frustration about their sense of self. As a youngster, Norman Fong's good friend Tommy Lim had once said that he "hated" being Chinese and that all he really craved was to "fit in." Retired CPA Ron Jung had said

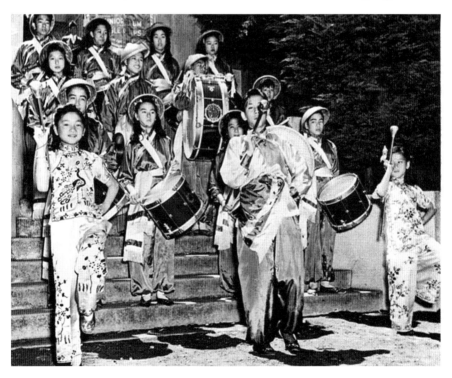

Prewar American Legion Cathay Post Drum and Bugle Corps. The photo includes five relatives of fourth-generation ABC Steve Tong. *Courtesy of Steve Tong.*

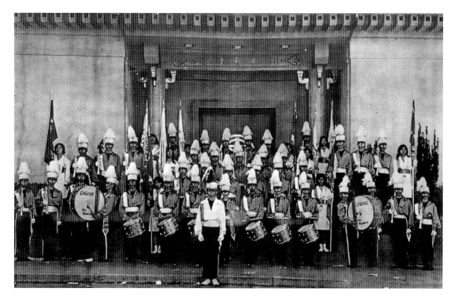

The Cathay Post Drum and Bugle Corps updated to "all-American" uniforms in 1963. *Courtesy of Jack Woo.*

of his first day of school that his was the "only foreign face" in the entire classroom. Even to the present day, he remains uncertain if he is "American enough" or "Chinese enough."

Referring to how he viewed himself as an adolescent, Norman said: "I was probably totally confused. Because of the split culture. I guess because, you know, speak English only in the morning (at school); speak Chinese only in the late afternoon (in Chinese school or at home)."[7]

The arrival of the relatively novel martial-arts genre of Chinese films in Chinatown's theaters in the early 1960s brought considerable relief to many of Chinatown's identity-challenged adolescents. Television and comic books, wildly popular in Chinatown as anywhere else, were bereft of any Chinese characters (or others who bore Asian features) that were not buffoons or villains. This was especially clear in the case of post–World War II comics, in which exaggeratedly caricaturized "Japs" were often depicted as "rats" or "yellow skinned monkeys."

These films from Hong Kong and Taiwan, often set in historical times, were replete with attractive costumes and sets. The plots were typically straightforward demonstrations of right against wrong, but the films were far more fast-paced and action-packed than their closest American counterpart, the Western. The always handsome or pretty Chinese good

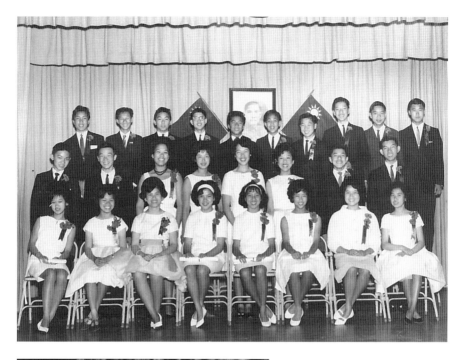

Above: Chinese Central High School class photo, 1965. *Back row, right*: future California state senator Leland Yee. *Courtesy of Jack Woo.*

Left: Jack Woo in his Chinese school marching band. Jack says he enjoyed the band far more than he did classes. *Courtesy of Jack Woo.*

guys, as likely to be a female heroine as a man, bravely and fiercely confronted foes in fantastically choreographed scenes. The battles, fought barehanded or with swords, never failed to include superhuman flips, twists and circus-like acrobatics. The more fantastic human feats included special effects that provided actors with the ability to run across water, leap backward over rooftops or snatch flying poisoned darts out of the air.

The films offered more than a momentary escape from reality. They provided a morale-boosting glimpse of self-worth and individual potential. Norman Fong and his friends began to see themselves in a more positive light. "On the English side you don't see any Chinese-American heroes. Not one. And then on the other side, go to Chinese movies and see Gung-fu stars.[8] It was good that I had some role models."[9]

According to Brad Lum, Chinatown boys began to sign up for kung fu training because they had finally found heroes like themselves that they could emulate: "The sword fighting epics came to Chinatown. That's when we all got hooked and went down to the Sun Sing and Great Star. And we all signed up to learn Kung-fu at that time. That really kind of brought it [our sense of self] up a notch. Eight-Eighty. It was just an address [for the kung fu studio founded by grandmaster Wong Jack Man at 880 Pacific Avenue] and it wasn't the name of a gang but that's what ended up happening: they called us the 'Eight-Eighty Boys.'"[10]

Norman Fong, one of the 880 Boys, added:

> *All of us kids hung out here at the 880. This is where we made pretend that we were Gung-fu stars. Friday nights, you could see everybody here. Maybe a hundred guys. And then sometimes we would come out here* [onto the sidewalks in front of or just beyond the studio] *to practice…just practicing you know? And sometimes we would even fight each other and sometimes it would even hurt, man! Eight-Eighties; it was fun! It was guys hanging out and we feel good about ourselves.*[11]

The self-affirmation motivated by the films did not affect only boys. Looking back to her younger days living in Chinatown, Amy Chung remembered being amazed and impressed at seeing Chinese persons portraying roles that had hitherto been absent in her life. "*Dragon Inn*, I think it was called in English and it was really the precursor to all those Gung-fu movies.[12] And what really impressed me was the fact that the hero to this movie was female. She was amazing. Little toughie."[13]

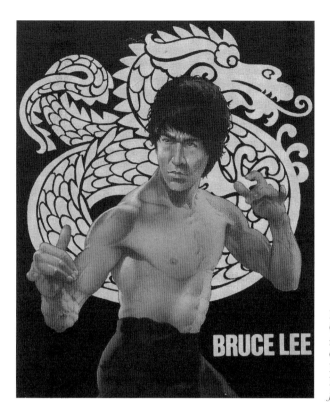

Film star Bruce Lee. Other Chinatown film role models included Cheng Pei Pei, Ivy Ling Po, Jimmy Wang Yu and David Chiang. *By author from VHS box art.*

Many of the martial-arts film actors, whether male or female, also appeared in films set in modern times. These included romances, dramas and musicals. Amy spoke about how she felt the influence of some of her favorite actresses when they performed in films set in the current times:

> *Living in Chinatown you were kind of on the fringe; you weren't really mainstream. What I remember from* [actresses] *Jiang Pui Pui and Siu Fong Fong was that they were people I could relate to. With the go-go boots and the A-line skirts and the hip-huggers; that whole generation of* [Chinatown] *teenagers emulated those* [Chinese film] *girls. Obviously we all had that kind of clothes, but you never quite look like everybody else* [who were not Chinese] *at school. I mean, obviously we would never look like Twiggy or Penelope Tree* [popular British fashion models of the 1960s]. *Seeing somebody dressed in A-line skirts and acting very independent and apparently cool; it just spoke to us.*[14]

PURPOSE AND DIRECTION

"An Ethnic Awakening"

Irene Dea Collier is now happily retired from a long career as a middle school social studies teacher in the San Francisco school district. As a teacher, she was a strong advocate for a more ethnically accurate and inclusive school curriculum and a voice for the protection of minority teachers' rights. Irene recalled the onset of the '70s, when most of Chinatown's baby boomers had already finished high school:

> *When we went to college, there was suddenly an ethnic awakening. Everyone wanted to find out who they were. And we had to just figure it out.*
>
> *For me, an accumulation of things might have surged into my conscious mind at the time. The way I was once told that I did "not belong" at the Woolworth's lunch counter when I was twelve, or the way some of our high school teachers looked down on us for being Chinese, or the lousy wages my mother got for making highly priced clothing that was sold in big-name downtown department stores all sort of kept nagging at me.*
>
> *A friend once said that he thought I was always a sort of quiet or timid sort of person. I don't think that's true. I think that I've always expressed myself freely and openly. Even when I was a child back in our village in China, I would run around barefoot and scream as loudly as I could about things I didn't like. The village ladies all knew who I was for it, too.*[15]

Despite being retired, Irene keeps busy. She has said that she wants to "slow down." But in the very same breath, she adds, "But my conscience rises up to say that I need to do useful things. I should continue to contribute." Irene recently took a break from working on a middle school reading list that she wants to make more inclusive, with titles by Asian American authors, to reflect on a lifetime of striving to be a force for positive community improvement, growth and development.

> *In college, I participated in the strikes at San Francisco State. Among the things that we wanted were courses that were inclusive and accurate in depicting all the things that non-European immigrants did to help get our country to where it is today. I had been in a class on the history of immigration where a classmate and friend asked the professor, "What can you tell us about the contributions of the Chinese to America?" The*

response was that they were "not significant." We were angered, irritated and just thoroughly pissed at that. Eventually, the administration paid enough attention to our insistence that it offer courses on Asian American studies, Latino or Chicano studies and "black studies." "Black studies" are now African American studies. The first of these courses were poorly organized and taught by people who weren't really professors, but eventually they improved and became a part of the accredited curriculum.

After I graduated, I got credentialed and went into teaching. It wasn't long before I saw a need for more non-Anglo teachers in the city's system. I mean, where was there any balance in such a multicultural city as San Francisco when the majority of schoolteachers were white? Furthermore, whenever the budget needed trimming, the nonwhite teachers were always the first ones to be let go. Since it was the '70s, they were typically recent hires and the old policy of "last hired, first fired" was used to justify their dismissals. As a member and later as the president of the Association of Chinese Teachers, or TACT, I fought against anything like that. I went before the board of supervisors and argued that these teachers, no matter that they were the most recently hired, filled specific needs that would go unfulfilled without them. They were retained. I also pushed for dual-language programs and more ethnically inclusive reading lists. I fought against Muni's attempt to raise bus fares for students from a quarter per ride to seventy-five cents. A lot of kids in the schools live in poorer neighborhoods. I myself wasn't so far removed from that very situation. A dollar and a half every day to get to school and back would have been a major financial strain on struggling families.[16]

FROM STRIKER TO ASSOCIATE DEAN

"By Any Means Necessary!"

Like Irene, Laureen Chew was a student at San Francisco State during the 1968–69 student strike. Although she had entered college as a quiet, somewhat naive girl still in her teens, Laureen was harboring past resentments that were soon to bloom. Increased awareness and sensitivities to the needs of their communities caused disparate groups of students—ABCs from Chinatown, members of the black and Hispanic communities and Native Americans, among others—to coalesce on campus to voice their concerns.

Speaking in 2007 from her on-campus office and as the associate dean of the College of Ethnic Studies, Laureen looked back to her student days, when the cry across campus was, "On strike! Shut it down!"

We were many groups that formed the (broader) Third World Liberation Front, so there were different student groups; so I was part of one group. The organization evolves because different individuals got involved with TWLF…and then…they all needed their own individual group to be responsive to. I think that the main thing people forget was that the activities were not only on campus, but also off campus. Academia at that point didn't have anything that we now call community service learning, community involvement so many of the students found it to be our responsibility to be connected with the community as well as with the campus.

The strike didn't happen until I was about a junior. I had befriended another Chinese American girl who started to go to organizational meetings with the Black students and then the other Third World students. Then she goes, "You gotta come with us!" And I go, "No!" Of course, I went and we did have many similar experiences in the sense of a cross ethnic group.

My father had a business in Chinatown. And then it all came together in my mind. I had noticed that any time a white customer had a problem in Chinatown with the way we did our job…especially in the family laundry when my father was in the front they would say things like, "Oh, you stupid Chinaman! You lost my sock again! What the 'f' is wrong with you people?" And I didn't understand. My father's reaction to it was really weird; he was like "Hahaha! Yeah, I'm so sorry!" He would just kind of laugh it off. And I'm in the back folding the laundry and getting like pissed off! I wanted to say something. I couldn't because I didn't know what to say.

Once we were ready to strike the saying was, "By any means necessary." It's a very Maoist saying. Many of us were Maoist 'cuz it was time to be a Maoist and to be a communist and to be anything out of the ordinary, especially the right or the middle; we were totally the left. We were labelled radical for nothing. I mean, I didn't care. My mother would have cared; my father would have killed us. But me? We really didn't care what the consequences were.[17]

Once the strikes were at their height, law enforcement was brought onto campus and things got heated. Laureen remembers:

I don't know where all these cops came from. They had the Tac Squad…
horses…they just surrounded us. I know this guy, he was a friend of mine,
and he was three persons in front of me and they just started swinging their
batons. I saw his head get bashed and it was horrific. I almost passed out!
I was screaming, "Get him outta there!" I was trying to pull him in, but
it was people on top of people. It was horrible. That bloodshed that day.
I just don't understand how those people could do that. But they did. And
we stood there for hours waiting to get booked and put in the paddy wagon
for downtown.[18]

Laureen found herself at the downtown jail along with hundreds of her
fellow protestors. She continues to express disappointment that her belief
in truth and accuracy on the part of the government or the media was
glaringly absent when events as she saw and understood them were at best
not reported at all and at worst misrepresented.

The day we got busted they took us down to Bryant Street. There were 400
people there, except the men and the women were on different floors. And
when we were in there, people were still protesting. They were screaming,
"On strike! Shut it down!" The whole building shook. Well, before I knew
it they were trying to quiet us down. First, they shot a gun to scare us, but
it was shot in the air so it didn't scare us and we kept on yelling. I didn't
because I was like, "Forget it." The next thing I know I was sitting on a
bench and this huge blast of water knocked me from my seat up against
the wall. Certain women had their arms and legs broken. I was totally wet
and scared.

And so we decided to hold a press conference the next day. And every
channel came.[19] *We told our side of the story as to how mistreated we were.*
And it was cruel to have seen people get hurt like that. And I was like,
"Finally! They're going to tell our side of the story on TV." Later when I
was out of jail I turned on every channel. Well, they had very little except
CBS, Channel 5. And they had the Sherriff's Department come on and
that was the only thing they showed. Not our side of the story. Well, the
Sheriff's Department said that these women were defecating on the floor and
we did not use high pressure hoses, we used garden hoses to clean it up. And
no one was hurt. The only people that recorded it accurately was KQED.[20]

Mark Zannini had many good and close ABC friends from Francisco
and Galileo who introduced him to their activities, experiences, families

and homes in or near Chinatown. Mark relished the opportunity to learn about and take part in the things that his ABC friends liked. While he did not take more than an observer's role in any of the Asian American activist movements of the late 1960s and early '70s, he nonetheless felt that he had gotten close enough to them to want to offer his thoughts from those years.

I believe that our Galileo graduating class of January 1966 was, in my own words, "The Last of the Squares." We had in Chinatown what I relate to as a version of the experience depicted in the film, American Graffiti. *Ours, I felt, was to be the last time high school and graduation would feel as it did in the era prior to the revolutionary '60s. I had many friends in the graduating class that followed mine in June of 1966 who were already starting to reflect the cultural changes that came with the rise of the Hippie movement in San Francisco: colorful clothes, changing hair-dos, Peace buttons on their jackets. However, pictures of our class in the 1965 yearbook show barely a trace of Beatle haircuts or mod clothes—especially among the ABCs. Styles were either tending towards "getting ready to grow up and go to college and on to marriage and business" or "still hanging in the hood, working at the gas station and playing pool." There were small hints that some in our class might embrace aspects of the coming revolution that included the response to the Vietnam War, recreational and at times dangerous drug use, and the Women's Lib movement. Another cultural trend that was to affect my friends from Chinatown was the practice of "shacking up"—living together without getting married. This was shocking enough in middle class White America but in Chinatown it was a huge challenge to people whose cultural history practically equates family to religion. Some in my class who were going steady married in one or two years after high school but much fewer in comparison with the period just a few years before.*

In the next three years I would see and experience a cultural revolution in Chinatown that was both similar and quite different from what was happening in San Francisco at large and the nation as a whole. In Chinatown the influence of what the Black Panthers were doing was felt in the establishment of activist groups such as the Leeways and the Kearny Street Workshop. Alex Hing and others started the Red Guard which was an even more flagrant and radical cultural response. Reactions to the Vietnam War ranged from open anti-war attitudes to young men who acted patriotically by volunteering

A majority of Chinatown's high schoolers graduated from Galileo (viewed from Polk Street). Inspired by its namesake, the school has its own observatory. *Photo by author.*

in the military. Drug use was becoming common; casual marijuana and some experimentation with psychedelics, but also street drugs such as Quaaludes and tranquilizers were having their effects. Rising ethnic pride and the popularity of Bruce Lee brought Chinese martial arts out of the cultural closet and into the public consciousness and established a new image of masculinity. The classic Mao jacket and cloth gung fu shoes became common items of garb. The image of Chinese Americans as seen by the broader public was being transformed from the too long-held stereotypes of inscrutability, subservience and deviousness portrayed in Hollywood movies. Other popular as well as the seemingly positive clichés were also being altered: not all ABCs were studious and obedient sons and daughters. My ABC friends were finding themselves and living lives independent of their families and the old traditions that had been with them since they were born.[21]

PRESERVING THE CHINATOWN COMMUNITY

Organizing and Fighting Back

Since the days of his youthful struggles, Norman Fong has become a highly respected figure throughout Chinatown, and he has lived by his own words to organize and "fight back." Norman's has been a responsible and reasonable voice that advocates for his Chinese community. Over the past thirty years, Norman has remained in Chinatown, where he has been creating youth programs, working in neighborhood planning and empowerment and advocating for affordable housing. He is also the present-day executive director of the Chinatown Community Development Center (CCDC).

Norman became interested in community service early in his life. As a youngster, he was familiar with Cameron House and the Presbyterian Church in Chinatown. Like many generations of Chinatown residents before and after him, Norman participated in many of the Chinatown-oriented youth activities offered by Cameron House: sports, arts, camping and carnivals. He also understood that Cameron House was an organization dedicated to support and benefit the Chinese American community that surrounded it.

When he was a boy, Norman's family lived on the very edge of Chinatown. One day, the building occupied by the Fongs was sold. The family was evicted, and none of its members had the least idea about what to do or where to go. Cameron House stepped up to their assistance, and so did the Presbyterian Church. They helped with temporary shelter and supplied basic services until their resettlement efforts met success. The abundance of kindness and support given to him and his family made a lasting impression on Norman.

As a way of repayment, young Norman volunteered to help with the Cameron House and Presbyterian Church community outreach activities. He participated in a food delivery program to people living in Chinatown single-room-occupancy tenements. These places were, and remain, perpetually crowded, dark and insalubrious. The tenants have to share kitchens and bathrooms that are down the hall from their rooms. Norman continued to work with Cameron House throughout his high school years and ultimately became day camp director.

Currently a parish associate with the Presbyterian Church, Norman has undertaken the support of the current Chinatown community as his primary life's goal. He said: "My mother was American born, and my father came through the immigration station on Angel Island. My mother was

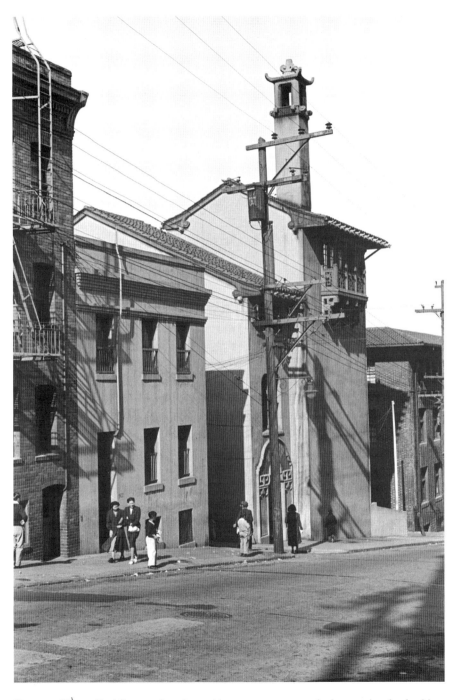

Cameron House (*far left*) was a fun place with games, sports, carnivals, camping, leadership skills and spiritual growth. *Ken Cathcart Collection. Courtesy of Schein and Schein.*

born in 1919, and she lived her entire life in Chinatown. When she was older, I promised her that I would always do all that I could to preserve her neighborhood and help make it a good place to live."[22]

Amy Chung, another ABC from Chinatown, has also been active with the Chinatown Development Center. Her background in law and real estate helped her spend over two decades as a vice chair for International Hotel Senior Housing, Inc., where she concentrated on resisting the forces of neighborhood gentrification that would have displaced many of Chinatown's residents and businesses. In the late 1960s and early '70s, the original International Hotel on Kearny Street became the focal point of a landmark struggle for fair and affordable housing in Chinatown.

The hotel had been standing since 1909. By the mid-1960s, it was one of the few places that the city's aging and mostly male Filipino population could call home or neighborhood. Practically all of what had once been Manilatown, the Filipino equivalent to neighboring Chinatown, had been bought, bulldozed and rebuilt as part of San Francisco's Financial District. Residents feared that similar encroachments into Chinatown would not be long in coming.

The final outpost of the once-thriving Filipino American community was sold and slated for demolition. Investors purchased the I-Hotel in 1968, and two years later, a former executive director of the San Francisco Redevelopment Agency was quoted as saying, "This land is too valuable to let poor people park on it." The almost two hundred residents were given notices of eviction. Asian American students at UC Berkeley and SF State were galvanized by the type of ethnic awakening mentioned by Irene Dea Collier. Many of these students had enrolled in the Asian American studies courses created in the aftermath of the 1968–69 strikes at San Francisco State. They rekindled their involvement with the campus-based Third World Liberation Front. The principle most strongly espoused by both coursework and the Front was that of returning to one's community to work and, if need be, fight for justice. The cry of "Save the I-Hotel" was born, and as Irene Dea Collier said, many of the young Asian Americans seeking further and deeper meaning in their cultural origins took action. Protests and demonstrations led to court fights that tied up the eviction and demolition process for years. Finally, in August 1977, police broke through a cordon of vociferous protestors to enact the long-delayed evictions.

The building was soon demolished. The Chinatown kids of the 1950s and '60s who had organized, fought and gave no small measure back to the community that fostered them were ultimately rewarded, however. A

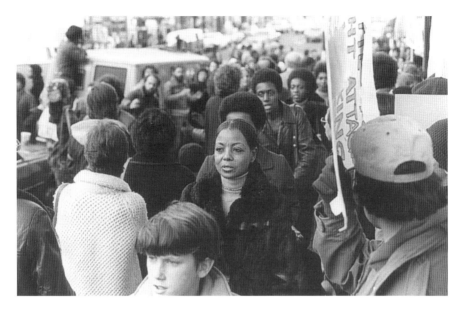

Heightened social awareness throughout Chinatown led to protests against the eviction of International Hotel residents in 1970. *Getty Images.*

new International Hotel was completed some quarter of a century after the demise of the original. The current hotel, built in partnership with the Archdiocese of San Francisco and the community, includes slightly over one hundred units of affordable senior housing and became the new location of Saint Mary's Catholic School, which had been formerly located on Stockton Street.

Recently, Norman Fong very likely echoed the pride and sense of accomplishment of many when, standing in Portsmouth Square (in the neighborhood's heart), he spoke about Chinatown: "This square is where it all began. The Chinese community fought to save this neighborhood and it's the first Chinatown in the whole country. This is where Asian Americans began. Right here!"[23]

Norman's ongoing youth-oriented programs at the CCDC have included alleyway renovation and beautification and hands-on support efforts for the elderly and economically disadvantaged. Still, neither Norman nor Amy nor any number of former Chinatown kids has any illusions about the future of their old home and neighborhood. While it is far less family oriented than it was in the 1950s and '60s, it still remains densely populated, with an estimated seventeen thousand residents, about 50 percent of whom live in cramped single-room quarters reminiscent of those of the old International

Hotel. The fight to keep rents affordable will continue in the face of pressures from the ever-expanding and neighboring Financial District.

Norman spoke for more than a few when he emphatically offered the following statement: "I love serving my home community of Chinatown and San Francisco!"[24]

The American Planning Association named Chinatown as "One of the ten great neighborhoods in America." The APA, a nonprofit organization, says that its mission is to advocate "excellence in planning, promoting education and citizen empowerment, and providing our members with the tools and support necessary to meet the challenges of growth and change."

A Little More on Identity

"This Is Me!"

Parents usually spent weekdays at work, so it was both convenient and logical that grandma should help out. Quite a few of Chinatown's kids were reared by a grandmother who grounded them in the ways and traditions of China. Some of their own children have been likewise nurtured by a grandmother. *Ngin-ngin* is the thlay yip (say yup) variant of Toishan Chinese for paternal grandmother, while *paw-paw* refers to the maternal grandmother.

One former Chinatown kid who was born at the Chinese Hospital was cared for by his *ngin-ngin*, who watched after him for about a year before he was old enough to start school. He remembers that his grandmother's daily conversations with him, along with some of her more fantastic stories, taught him how to speak Toishan Chinese fluently. This same grandmother taught him how to write a little in Chinese.

My grandmother showed me how to write in Chinese. She taught me quite a few of the basic words, among them man, woman, good, big, mountain, gold and the numbers from one to ten. These characters were fairly easy for me because the most challenging one only consists of six strokes of the brush, pencil or pen. Chinese characters can be learned by memorizing the order of each of the strokes required to create them. If she had been able to spend more time with me, I am certain that I would have learned a great many more characters. I would not be able to spell "mountain"—an easy three-stroke Chinese character—in English for another two to three years.

The youngster's grandmother entertained him with many stories in Chinese.

> *One of my grandmother's stories was a scary one about an evil dragon. She said that when she was little the family home and those all around it was tormented by a huge and mean dragon. People would not go out at night because they were afraid. The dragon had eaten some people, and nobody wanted to be its next victim. One day, according to my grandmother, she was out walking on the nearby mountain. She heard noises around the bend, and when she turned the corner, there stood the dragon. My grandmother began to cry and she shut her eyes. She had some oranges with her, however, and she held one out at arm's length with her eyes still closed tight. She felt a powerful rush of wind and thought she had just been eaten. She stood still for a long time and finally opened her eyes. The dragon was gone. Nobody saw him again, but whenever there was an earthquake, everyone knew that it was the dragon twisting and turning in his underground lair.*
>
> *It was a great story for me as a child. I told it to my own daughter when she was at that age when sitting on Dad's lap for a story was so much fun for her. I told it in English, of course. I could never, no matter how hard I try, tell it in Chinese. My grandmother was a huge early influence on me, and I remember her with great fondness. I feel badly sometimes that I let the things about China that she talked so lovingly about just become irrelevant to me in my life as an American.*

Sherry Pang is a fifth-generation Chinese American and native San Franciscan. Happily married and with two grown children, Sherry talked about being Chinese or Chinese American:

> *When my children were young they stayed with their paternal grandma during the day. She spoke to them in Chinese. I think my son still understands quite a bit but he has to answer her in English most of the time. In our own home we don't do very many traditional Chinese things and I don't know how to make the different foods that are part of the Lunar New Year celebrations.*
>
> *Grandma doesn't force her traditions on us or the grandchildren, but there are certain things she would ask us to do, like visit the cemetery on the appropriate dates for the honoring of ancestors. If she asks us once and the answer is no, she won't pursue it. We generally go because she doesn't ask that much of us and it makes us happy to be able to take her.*

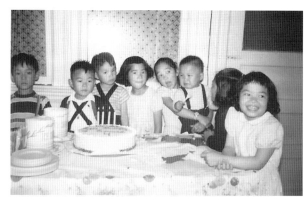

Left: Cake, ice cream and an American-style birthday celebration, 1952. *Author's collection.*

Below: Christmas with gifts from Santa at Grandfather's Chinatown flat, 1949. *Author's collection.*

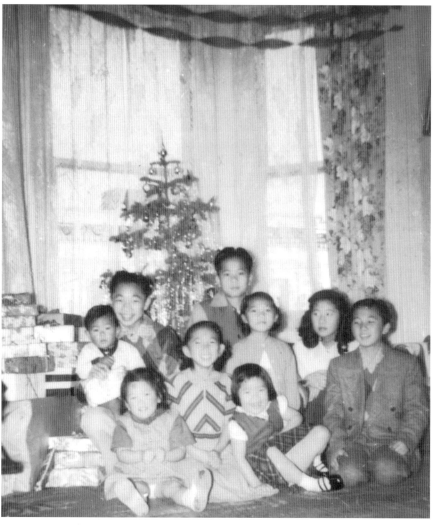

It doesn't bother me that we are not traditional Chinese. If we eat Chinese food at home, my husband is the one who makes it or we bring it over from grandma's house. When I ask my son what he thinks we ought to do when he gets married, he says that we should have a Chinese banquet because we're Chinese. Sometimes I feel we are floating in the middle between being Chinese and being American, but on a personal level, this is not a problem for me.[25]

Cecilia Wong comes across as being very much Americanized as she expresses herself with considerable certainty about her feelings: "I have a new boyfriend now and he's Chinese. And I was over at his apartment and I opened the (kitchen) cabinet and inside is fish sauce, and soy sauce, and he had oyster sauce. I suddenly felt like, 'This is me!' I feel comfortable. This is what I want. My ex-boyfriend; he had baked beans and ketchup in his cabinet. And I eat those things as well, but it's just different. I don't want to spend the rest of my life with half of me missing."[26]

2

SHOWTIME AND MOVIE NIGHTS

"SOMEONE GOT THE BRILLIANT IDEA TO SET OFF SOME FIRECRACKERS IN THE BALCONY"

*C*ertain films eventually led some Chinatown teens and young adults to become community activists. As children, however, all any of them and their young friends wanted was to have fun at the movies. From the 1950s through the 1970s, seven movie theaters could be found in the Chinatown and North Beach communities. Most of these theaters were in Chinatown itself. The Sun Sing, whose brightly colored front modeled a traditional Chinese architectural design, was on Grant Avenue. It showed Chinese films and would host occasional live performances of classical Chinese opera. There were two theaters on Jackson Street: the Grandview, between Grant and Stockton, and the Great Star, one block down the hill between Grant and Kearny. The Great Star also hosted live opera performances. The Bella Union was on Kearny Street between Washington and Jackson. It had been operating since 1911 as a live entertainment venue and then as a movie house showing American and some European films. The theater struggled after World War II, but it was revived in the 1950s to show Chinese films. The World on Broadway, between Grant and Stockton, opened at about the same time as the Bella Union and originally showed late-run American and probably Italian films. By the early 1950s, an upsurge of the Chinese population in the area led the World to offer Chinese movies exclusively. The Palace was in North Beach at the intersection of Powell and Columbus. It opened shortly after the 1906 earthquake and fire as a live vaudeville venue. Live acts gave way to films; by the 1950s, the Palace was one of two Chinatown-area theaters showing American movies. By the late 1970s, the Palace was renamed the Pagoda and primarily showed Chinese

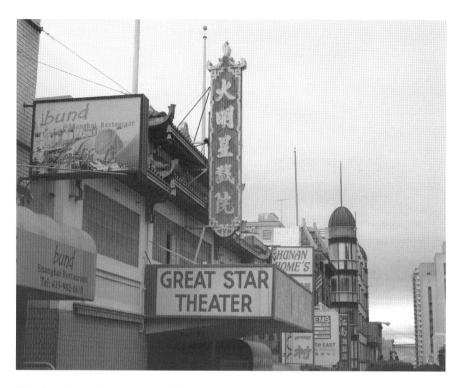

The Great Star Theater, where Chinatown's kids thrilled to the martial-arts exploits of their film heroes and heroines. *Photo by author.*

A "movie star" itself, the Sun Sing Theater was featured in Orson Welles's 1948 film *The Lady from Shanghai. Courtesy of Cooper Chow.*

films. The Times, on Stockton near Broadway, was also an early twentieth-century live entertainment theater until the advent of motion pictures. By the 1950s, it was showing bargain last-run American movies and, sometimes, dubbed low-budget European films.

MEMORIES OF A FIGHTING FAVORITE

"Hey! I'm Wong Fei-Hung!"

Sherman Wong, a semiretired veterinarian who lives on the peninsula, remembers his earliest visits to the movies:

> *Even when I was very little, my parents took me with them to the movies because they didn't want to leave me home alone. We usually went to the Great Star, which is still there, on Jackson Street. It was closed for a while, but it was recently renovated and they use it for special films or the Chinese opera now. Sometimes, we went to the Grandview that was just a block away. Most of the time I didn't really like or understand the films, but I always got a little money for the concession stand and that was good. They*

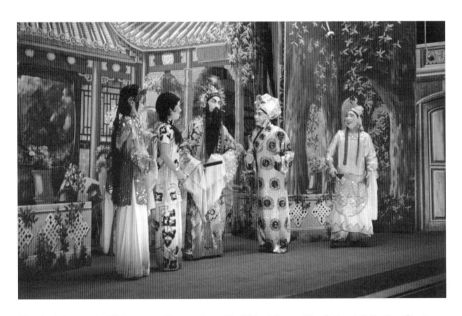

Classical theater in Chinatown. Parents loved it; kids did not. *Ken Cathcart Collection. Courtesy of Schein and Schein.*

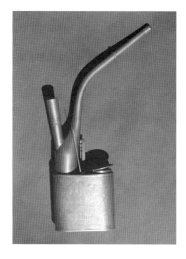

Kung fu standout Wong Fei-Hung often carried an opium pipe just like this one in his movie scenes. *Photo by author.*

sold American candy and Chinese snacks, and I usually got American candy. My parents usually got the Chinese stuff like mui [dried and preserved fruit] or ga-doo [melon seeds]. I never could get the hang of those seeds. They were dried watermelon seeds and you had to crack them open with your teeth. I just couldn't do it. They would get wet from saliva and then be too slick to hold down. But the old folks were really good at it, and the whole floor of the theater would be covered with those cracked seeds.

Whenever there was live Chinese opera playing at a Chinatown theater, my mom would make a big deal out of going. It didn't mean that much to me, of course. The costumes were really fancy, the music was loud and the women would sing in really high falsetto voices. I just wasn't that interested. If any of my friends were there, also dragged along by their moms, we would get together and just mess around in the aisle.

Every now and again, though, there would be a good action movie. All of our favorites were the ones about Wong Fei-Hung.[27] His were kung fu movies, and the actor that played him [Kwan Tak Hing] was like the Jackie Chan of our day. Action and fighting…that was great. After seeing one of his movies, all of us would run around saying, "Hey! I'm Wong Fei-Hung!" and act out the fighting scenes with each other.[28]

A GIRL'S SURVEY OF CHINATOWN'S MOVIE VENUES

"I Saw Bruce Lee Perform Live"

Judy Wing Lee, now retired and living in Hawaii, recalls her childhood experiences at several of the Chinatown movie houses:

My mom used to haul me to see movies with her after she got off work. She would bribe me with treats from the concession stands. Some of the Chinese

stuff that they had included mui (one type was desiccated and salty plums), cuttlefish (dried and salted squid-like cephalopods) and preserved ginger. The World, Great Star and Sun Sing had their own snack bars, but there wasn't one at the Grandview. If you went to the Grandview you would have to buy snacks from a nearby store. The theater was pretty good about letting you in and out after the show had already started. The Great Star also showed American movies for a little while. I remember seeing The Manster *and* Circus of Horrors *there. Great Star and the Grandview had the creepiest restrooms. They were downstairs in the basement. The World and the Sun Sing had them upstairs.*

I asked my mom why we had to see so many Wong Fei Hung movies at the Sun Sing. She said that they were the only movies offered in the 1960s. I now know that that wasn't a reason; Wong Fei Hung was simply a very, very popular character. One time in the early 1960s, before he ever became famous, I saw Bruce Lee perform live at the Sun Sing. He did a Kung Fu demonstration as an opening act for Diana Chang Chung Wen, who was a Chinese bombshell in those days. She was a really beautiful and popular movie actress from the 1950s and 1960s. She was on a U.S. tour and she was called "the most beautiful creature in Free China." After his martial arts act, Bruce danced the cha-cha with Diana up on the stage. Afterwards he stood around in the lobby. Even then he had a presence.[29]

Street stalls like this on Jackson, Washington and Clay Streets sold plenty of five- and ten-cent Chinese and American snacks. *Ken Cathcart Collection. Courtesy of Schein and Schein.*

Hoover Ng does not have quite the fond memories of Chinatown's movie theater snacks as Sherman or Judy:

> *If you were really from Chinatown, you knew that no one, but no one would ever buy anything from the concession stands. Everything they had was stale. We always brought our own snacks. I always brought my own ga-doo. Everyone had them. All through the movie you could hear them click and snap between people's teeth. Then you could hear the soft "pphhht" as the split shells got half blown and half spit onto the floor. When you got up from your seat you could feel and hear the shells as they crunched under foot. I loved cracking those melon seeds and throwing them on the floor. I also really loved all the Wong Fei Hung movies.*[30]

Walden Jay was another moviegoer who also preferred to bring his own snacks: "It was great to pick up an order of chow mein from Sam Wo to eat while watching action-packed Kung-Fu flicks."[31]

Mark Zannini grew up within the Italian American community of Russian Hill and North Beach. Because he attended Francisco and Galileo, many of his friends were ABC classmates. He spent a great deal of time with them in and around Chinatown. Mark recalls one of his first visits to the Sun Sing theater:

> *When playing with my friends in Jasper Place, I could hear the sounds of Cantonese opera wafting out into the streets from the little nearby sewing factories. I must have said something about what I could hear, because one day my friend Gerald invited me to go to the Sun Sing theater on a Saturday to experience the scene. It was definitely not what I expected—it was like a wild indoor picnic. The place was packed and steamy with mothers and their little kids and even whole families. I saw that people even brought their own food. The movie was almost secondary to the social experience. I sat in the balcony and watched people pass food around and talk throughout the movie. It made me reflect on how insular the Chinatown experience could be. As has been said about many ethnic enclaves, some people rarely left the boundary streets of the neighborhood and were able to experience their lives as if they lived in another country. When I got home and told my family about the experience, they told me that the Italians in North Beach used to do the same sort of thing as recently as just ten years earlier.*[32]

Poster featuring coming attractions at the sole surviving Chinatown theater: the Great Star. *Photo by author.*

Cooper Chow, like so many of his contemporaries who applied the words "torture" and "agony" to the experience, also complained about being dragged to Chinatown movies by his mother. Chinatown moms who wanted to see nighttime movies but who got off from work before their husbands did would often take a child (or several of them) along for company. In some cases, such as Sherman's, it was because they did not want to leave a child alone at home. For many of the youngsters, the movies were torture and agony because they had stopped using their once-native Chinese to such an extent that they could no longer understand the dialogue. One such individual stated that his total reliance on movie subtitles whenever they were available allowed him to develop a talent for speed reading. It was particularly tough on a child whose mother's show preference would be film versions of classical opera, a drama or a current musical. The lack of visible action and the dearth of special effects in such films merely added to a kid's sense of misery. Cooper disdainfully remembers some of the films that he now admits have become "classics" that he was forced to sit through. Among their titles were *Susanna*, a romantic drama with

singing; *My Dream Boat*, a complicated and tragic love story; and *Dawn Will Come*, a musical drama. The boys along with many girls would all have preferred the sword-fighting and martial-arts epics, even at a time when many of their special effects were pretty basic. One former child filmgoer remembers "cheesy painted-in power rays emanating from an actor's hand." He quickly added, "But we ate it all up." Within a few years, many of the boys would grow to appreciate the talent and the beauty of the bevy of Hong Kong and Taiwanese-based starlets featured in Chinatown's films. These included the sensual, seductive and provocative likes of Diana Chang Chung Wen (Judy Lee's "Chinese Bombshell"), Li Ching, Lily Ho and Ivy Ling Po.

EXAGGERATED SPECIAL EFFECTS

"To This Day, I Dislike Blood in Movies"

Melody Chan Doss-Wambeke lived at the foot of Telegraph Hill in North Beach. Her father was absent for long stretches of time due to his work in California's Central Valley. Melody's mother often took her daughter and her two sons with her to the movies.

> *I remember going to the Great Star with my mom and two brothers. Sometimes we watched a black and white film version of classical opera, but we also went to live opera at the theater. One time my mother saved enough to get us a family box seat. I tried very hard to follow the story line by concentrating really hard on the lyrics being sung. I had a really hard time following any of it so my mother tried to explain things to me. I was only eight or nine at the*

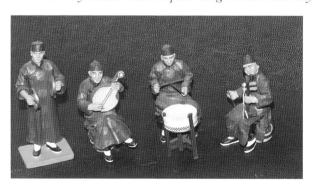

Scale figures of classical musicians with traditional instruments. Strings are the *Er-hu* (thin, upright) and *Ruan* (circular). *Photo by author.*

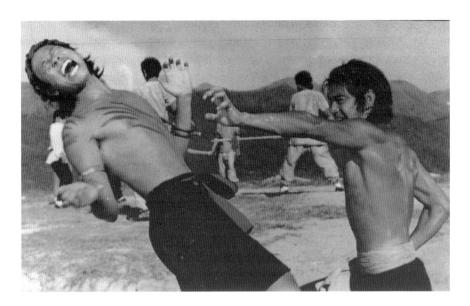

Exaggerated gore was a trademark of the fight movies. Shaw Brothers Studio provided Chinatown with a steady stream of such popular fare. *Photo by author from VHS box art.*

time, so I just couldn't keep up. Years later I discovered that the singing was in classical Chinese and not my everyday dialect.

We also went to Kung-Fu movies at the Great Star. I was a pretty sensitive child so the scenes with squirting blood, chunky red vomit representing a blend of blood and guts, sounds of cracking bones and crunching skulls really bothered me. Well-blooded cleavers and spears shoved completely through a character's body were also far from my favorite things to see. Thankfully my mother was very patient in reassuring me that it was all fake and done with paint or ketchup. To this day I dislike blood in the movies. After a show we would walk home from Chinatown to North Beach. It would be 11:00 at night, but a woman and three young kids had no trouble on the streets back then.[33]

FAMILY FUN

"How About Setting Off Some Firecrackers in the Balcony?"

A one-hour documentary, *A Moment in Time*, directed by Ruby Yang, was released in 2009. Running for slightly less than an hour, the film

commemorates the heyday of Chinatown's movie theaters. The film's narrative includes comments made by a number of persons who grew up in or near Chinatown. Chuck Gee spoke of going to the opera with his mother when he was still quite young: "We would go after the performance started and sometimes my mother would pay 25 cents and the whole family would go in. Everybody knew everybody. My mother would acknowledge all her friends. And we [kids] would all have our little friends and we would pal together and we'd run up and down the aisle not really paying attention to the opera itself. We would only pay attention when there were fighting scenes."[34]

Amy Chung, also interviewed for the film, had these comments to add: "I had gone with my grandmother and my brothers tagged along…and there was this gang of kids and they were running around. And finally somebody got the bright idea of, 'How about setting off some firecrackers in the balcony?' And in the meantime, on the stage, I remember guys doing somersaults…it was a three ring circus!"[35]

Later, as adults, some of these once rambunctious children took time to reflect on what some of the movies they watched had to tell them. Amy recalls: "Our reality was much closer to what we saw in the Chinese films… with (depictions and themes about) strong family structure and an emphasis on a good education and being dutiful to our family."[36]

Jimmie Lee, who also appears in *A Moment in Time*, supported Amy's statement. What Jimmie had to say was followed by a short clip from a film set more or less in modern times: "The problems and the situations that these movies brought to us were very real because we could see the same things happening here in the Chinese American families. We always saw how in the West papa and mama were friends of the kids whereas in the Chinese families, they were not. They were disciplinarians."[37]

The film clip showed an older man in the role of a father talking to another adult who is portraying his grown son. The son seems to be less than enthused by the prospect of his upcoming marriage, which had been previously arranged. In the film, the "father" shouts at his recalcitrant "son": "Your deceased grandfather arranged this marriage…no further discussion is allowed!"[38]

The Palace and Times Theaters

"I Grew Up Catching a Show There Every Weekend"

During the 1950s and '60s and slightly beyond, Chinatown was served by two movie houses that showed American films. There was the Times, on Stockton Street near Broadway, that charged fifteen cents if you were under twelve, and there was the Palace, located near Union Street and Columbus Avenue. The Palace charged twenty-five cents for those under twelve and showed second-run movies. The show at the Palace was always a double feature with a cartoon and previews between films. More so than the Palace, the Times often featured B movies with heroes such as Hercules, Aladdin or Tarzan. Many of Chinatown's youth were warned away from the Times by parents who claimed that it was flea infested or that it was patronized by *hom sup low*, or dirty old men. Some refute those parental claims, but one former patron remembers that his sister, about ten years old at the time, was offered candy and money for some "touching" by an adult male in the Times. They quickly left. Not far from the Chinatown and North Beach neighborhoods was Polk Street, where two other movie houses, the Royal and Alhambra, were located. While they were within fairly easy walking distance from Chinatown, they were first-run theaters that charged between seventy-five cents and one dollar for admission.

Darryl Eng was a frequent moviegoer at the Palace.[39] He usually went to weekend matinees in the company of friends or some of his cousins. He remembered:

> *I sometimes went to the Palace by myself because I knew that my friends and schoolmates liked the same types of films that I did. I would always run into someone in the ticket line that I knew. Most of the time there were four or five guys that I knew and we would sit together for the movie. We would see girls from school or the neighborhood also, but back in our grade-school days boys and girls didn't mix together very much.*
>
> *I spent many an afternoon at the Palace watching features that ranged from Academy Award worthy to barely fit for late-night television. Among the better films I remember seeing at the Palace were* The Bridges at Toko-Ri *with William Holden and Grace Kelly,* To Catch a Thief *with Cary Grant and Kelly,* Dial M for Murder *with Jimmy Stewart and* National Velvet *with Elizabeth Taylor and Mickey Rooney. Some of the Palace's less-memorable offerings included* I Was a Teenage

Frankenstein *and a Three Stooges marathon. My friends and I preferred action movies like Westerns or war movies. Sometimes, there would be a Disney full-length animated film like* 101 Dalmatians *or a teenager film like* Bye-Bye Birdie *or* The Parent Trap. *I also remember sitting through* Flower Drum Song, *the Chinese American–themed musical. I was not offended by its stereotypical representation of Chinese people so much as by the singing and what I felt was an overly girlish story.*

One time, one of my aunts and a group of women from the Chinatown Branch of the Lion's Club Wives went to boycott a movie at one of the downtown theaters. They even made protest signs to carry. The movie was called the Tong Wars, *and she explained that it showed Chinese people in a bad light and was not true anyway. My cousins and I didn't understand what she was talking about or doing. We asked if it would be OK for us to see the movie, since it promised to have fighting and violence with Chinese people like us in it. We knew enough to expect hatchet men to slash and hack at each other with axes and knives, and it was just the kind of thing we would have really enjoyed seeing. Only later did I understand and appreciate why she yelled at us and told us she thought we were just plain dumb and that she would lock us in the house to keep us from seeing the movie.*

We generally went to the Palace for weekend matinees that were double features with a cartoon in between. We were usually out by five o'clock, at which time the theater's concession stand offerings notwithstanding, we would be starving. We would rush back to Chinatown and go to the side or back door of one of several restaurants that we favored. There we would order a one-dollar box of chow mein directly from the cooks. A popular version of the time was "fan-keh-gnow-yuk chow mein," or tomato beef stir-fried noodles. We would then take our dinner to Portsmouth Square bounded by Grant Avenue and Kearny Street and Clay and Washington Streets. Sitting on a convenient bench among hopeful pigeons and old Chinese men, we would eat our fill. For dessert, we would stop by one of the sidewalk vendors on Jackson, Washington or Clay Streets for a nickel's worth of mui or lom. These were dried preserved plums in the case of mui and similarly treated olives in the case of lom. Because of their oblong shape, one of my aunts called lom "footballs." If she knew I would be going to the movies, she would sometimes ask me to buy her "ten cents' worth of footballs," which I would bring home to her in the miniature brown paper sack that the seller would put them in. Also available for a nickel or a dime were dried lemon peel and salted ginger slices. I once offered a salted mui to a Caucasian girl classmate at Francisco. I have never seen

a human face scrunch itself up so tightly so quickly. She was pretty nice about it and didn't get mad or think that I was playing a trick on her. Later I tried to get her to try ginger or lom, which are much milder than the salty mui. She would never go for it.[40]

Several former students of the grade schools that served Chinatown recalled that they received free passes to the Palace for being Traffic Boys. These boys were members of the school's safety patrol who would stand at the crosswalks leading to and from their school to keep their fellow students from stepping off the curb before they should.

One former Traffic Boy recalled: "I watched many movies at the Palace with my Traffic Boy pass from Hancock School. I had to pay to see the Beatles in *A Hard Day's Night*, though. My dad wouldn't let my sister go with her friends. I couldn't hear anything for all the screaming."

Another former Traffic Boy added: "[A friend] and I saw *A Hard Day's Night* at the Royal Theater on the first weekend that it was out. I've been hard of hearing ever since."

When told that other Traffic Boys had gotten into the Palace for free, a third ex–Traffic Boy expressed dismay: "No! What schools were they at? It wasn't Washington Irving, because what we got was like a certificate that let us in for ten cents. It was never free! I thought getting in for a dime was a good deal, but I guess I got gypped!"

Except for the Great Star, all of these theaters are gone now. Most have been refurbished for use as commercial spaces.

Walden Jay sums it up: "Those were wonderful times, our youth. I really miss going to those theaters in Chinatown."[41]

3

THE LONELINESS OF BEING GAY

"I COULD HAVE BEEN A DUTIFUL CHINESE SON AND FAKED IT"

\mathcal{D}arryl Eng was born in 1947 at San Francisco's Chinese Hospital.[42] His family lived in various locations within easy walking distance of Chinatown, and his father at one time or another owned several small businesses there. His mother was an ABC, as was the majority of her side of the family. Although he was born in China, Darryl's father arrived in San Francisco at a very early age and remained in the city for the rest of his life. Practically all of Darryl's older relatives on his father's side were born in China. His family spoke the *thlay yip* dialect of the Toishan area of China.

Although Chinese was spoken frequently in Darryl's home, his parents never talked about China. According to Darryl, his father never even talked about his own father, who was a prominent figure back in China and who was also the founder of one of Chinatown's community newspapers, the *Young China*. Of his father, Darryl said:

> My dad had an orchard near Isleton in Sacramento County, which is where one of his uncles had a tomato cannery. Some of my aunts on Mom's side would go to work at the facility during the summer canning season to help out and to get away from the city for a while. I heard this sort of information through the talk of aunts and uncles. I wasn't close to my parents, and there was never very much that was shared to me by either of them. One thing about them is that they were "anti-Chinatown," which I think is odd, because we shopped there, ate out a lot there and my father made regular rounds there as a wholesale liquor sales representative.

The Li Po bar has been around since the 1930s. Travel Channel star Anthony Bourdain recently fell in love with its famous mai tai. *Photo by author.*

After starting school, Darryl began to turn completely away from things Chinese. He had quickly observed that English rather than Chinese was to be the language of choice and that American history, culture and values were the norm. He quickly adapted. It was not long before he favored hot dogs over the traditional Chinese sausage *lop cheung*, sometimes called the "Chinese hot dog" by many ABCs of the time. Darryl also preferred to see himself as a cowboy hero like television's Roy Rogers or Hopalong Cassidy far more readily than as Wong Fei-Hung, the martial-arts champion of the

oppressed seen almost weekly in the Chinatown movie houses. Darryl even openly rebelled against the Chinese lessons he was sent to take.

> *I went for lessons from Dung Seen Sang, who had been a teacher in one of Chinatown's regular Chinese schools. She offered the lessons in a lobby space within her apartment building that was located on Montgomery Street just off of Broadway. This building of single-occupancy rooms was not luxurious or fancy, but it was far nicer than a lot of similar places found in Chinatown. There were several others in the class. Our parents had chosen Dung Seen Sang because she was willing to teach us in our own village dialect of thlay yip. The regular Chinese schools taught in Cantonese (and eventually in Mandarin), which would have been difficult and confusing for us.[43]*

Chinese Central High School, Jung Wah Hok Hau and the Chinese Six Companies. This is a former 1970s Chinatown anti-bussing "Freedom School." *Photo by author.*

貓　狗

弟弟洗菜　哥哥拔菜

Chinese school instructional chart. Reciting loudly pleased the teachers, even if not everyone understood what they were shouting. *Ken Cathcart Collection. Courtesy of Schein and Schein.*

So, there we would be at her building to take lessons in the basics of speaking, reading and writing. While she spoke in our family dialect, which we understood perfectly well, we were just, as they say nowadays, "not that into it." I remember once when we gently unscrewed the light bulbs of our study area so that when she turned the switch on there was no light. We fed off one another, and we began to do this somewhat regularly. The reward was that she would be totally perplexed and cancel class. Another time, we climbed up to the roof and were playing around when we were spotted by someone's mother who lived nearby. She reported us all to our respective parents, and boy, did we get it!

This sort of thing went on for close to a year. We sometimes actually sat through our poor teacher's lessons and behaved, but other times we were unruly enough to put her completely out of sorts. Eventually one set of parents decided that they were wasting their money, and all the rest followed suit. So much for learning Chinese!

CIRCLING BACK

"I Needed Something…an Identity"

Over the years, however, Darryl has become the "most Chinese" of all his siblings and cousins. He has relearned the language, which he speaks very well, and he is thoroughly knowledgeable about his family's native cuisine, traditions and customs. His renewed grasp of his heritage has so impressed his cousins that they often call on him for advice or assistance with things

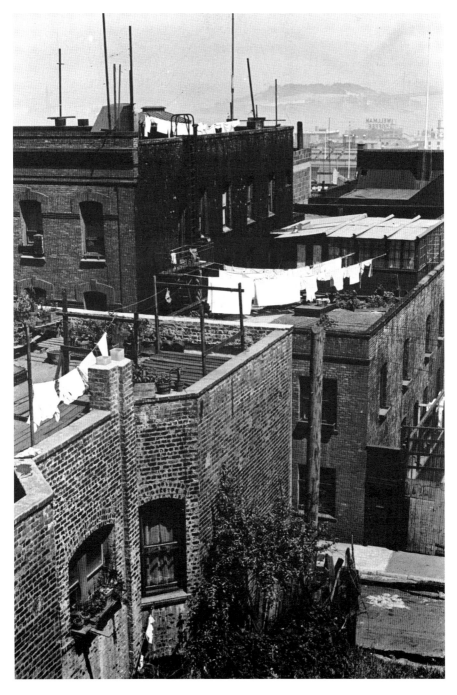

Up on the roof. Mom's laundry and flower garden, Dad's chicken and pigeon roosts, kids' play space. *Ken Cathcart Collection. Courtesy of Schein and Schein.*

like recipes, Chinese New Year celebrations, red egg and ginger parties, wedding practices, *bai sun* and more.

Darryl's return to his roots began in his late teens or early twenties. The journey was certainly in full bloom by the early 1970s, when Darryl landed a job with the State of California not long after finishing his time in the army. He was now in a position of sufficient financial stability to begin what has become a lifelong passion: collecting Chinese art and antiques. In addition to the reconnection to his past, Darryl has said that his collection of quality items, all well studied and researched, was to serve as an investment for the future. Darryl's plan was that if ever he should need money in later life, he would be able to sell items from his collection. Now retired, Darryl's home is filled with impressive and beautiful Chinese antiques and decor. The home is very well appointed, and most of his furnishings fully serve for the daily functioning of his household rather than to merely grace the premises as objets d'art as in a museum.

Darryl characterizes his collection as follows: "I do have good Chinese things in the house. Only a few of my pieces are museum quality, a few are close to museum quality and the rest are just quality. I have a scroll with a

Waverly Place, one of Chinatown's busiest and most colorful alleyways. *Photo by author.*

Interior of a Chinatown temple. Possibly Tin Hau ("Empress of Heaven") Temple in Waverly Street, founded in 1852. *Ken Cathcart Collection. Courtesy of Schein and Schein.*

Ivory carving held onto by Darryl Eng as "an investment for the future." *Photo by author.*

Chinese lady painted onto it and a vase that I was told bears Ming markings that are museum quality. Some of my items that are close to museum quality include a set of chairs and several bowls or vases."

Darryl adds that the following list of items would have been earmarked for sale had a bad financial situation befallen him.

Some of the good quality things include two sets of rice bowls that are late nineteenth century, a zodiac set that is porcelain/ceramic and some bowls or vases. They were a nice investment in that I paid fairly little for them and over time they have increased a lot in value. I could also have sold some scrolls, Chinese opera gowns or rugs. On top of all that, I also bought gold jewelry years ago, and I have at least a pound's worth of it scattered in various hiding places around the house. I'm retired now and I'm financially secure, so I don't have to think about pawning anything to raise money anymore.

With no apparent need for any form of financial liquidation, Darryl has instead begun to slowly gift items from his household to the younger members of his family as a legacy of their original culture.

THINGS NOT UNDERSTOOD

"I Felt Alone and Unwanted and Unloved"

Darryl explained the path of his eventual coming full circle from full rebellion to once again embrace what it is to be Chinese. It was a long and at times difficult process.

I think it was in my late teens or early twenties, but I am pretty sure that I really started getting back to being Chinese after I got out of the service. It was in the early '70s, and I was working for the state in Southern California. Having been born and raised in San Francisco, living near Chinatown and being fairly close to certain cousins and adult family members back there, I was a little out of my element in Southern California. I wasn't miserable or unhappy, and I was perfectly fine at work, but I would come back often to San Francisco to visit relatives or to take part in birthdays or Chinese New Year celebrations and things like that.

Of course, I needed a place to stay whenever I came to the city. My mom had passed away in the mid-1960s, and my father's was just not a place I wanted to go to. I wound up staying regularly with my Aunt Susan, who was my mother's eldest sister, and her husband, Uncle Frank. Over time, I became very close to them. They became the parents that I had always craved but never had. I remember as a child, going to see the Disney movie Cinderella, *and as I watched it, I felt alone and unwanted and unloved just like she did. I asked myself if I weren't adopted, and all through it, I just kept thinking that I must be just like that little girl* [Cinderella].

The problem with my parents was that by the time I was eight years old my mother noticed that I was showing signs and behaviors of gayness. This was a real blow to her. At that time, it was illegal to be gay. On top of that, as a boy, the automatic and unshakeable expectation was for me to produce a son. Not only would my parents be blessed with a grandson, but there would be an heir to the family name and fortune. Well, since I actually am gay, there wasn't going to be any chance of that. While the failure to live up to those expectations was mine, Chinese culture places the burdens of a son's shortcomings fully upon the parents. I, therefore, had brought shame and disgrace to all. I suppose, in afterthought, I could have been a dutiful Chinese son and faked it. I could have gotten married, sired a son and then have a gay lover on the sly.

Well, going back in time to my childhood, I was only eight and had no idea whatsoever that I was being anything [other] *than my normal self. My parents were not long in turning their backs on me. Many years later, I asked one of my aunts why she thought my parents didn't love me. She astounded me by telling me that, faced with the possibility of me being gay, my mother had considered sending me for the type of electroshock treatments that in those days were believed to be curative.*

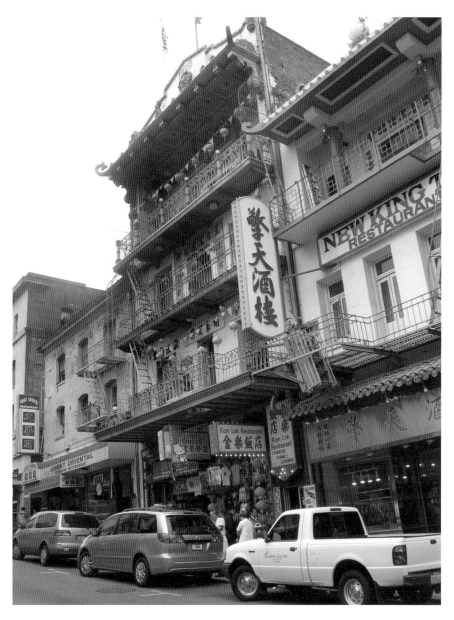

Washington Street has long been home to many specialty shops and restaurants serving Chinatown's residents. *Photo by author.*

On Being Chinese and Being Happy

"Uncle Frank and Aunt Susan Didn't Care about Any of That"

Well, Uncle Frank and Aunt Susan didn't care about any of that. They were welcoming, accepting and loving. They have since passed, but I will always cherish and honor their memories. Over my numerous short-term stays with them, I gradually began to gravitate more toward the Chinese culture. Aunt Susan was an ABC, and Uncle Frank was born in China, but he was a World War II veteran who had landed at Normandy for the D-day invasion in 1944. Nonetheless, they were really very traditionally Chinese. Their house was furnished and decorated in a Chinese style, and they always cooked Chinese food. Uncle Frank was the cook, and he was really good at it. Of course, while visiting them I couldn't let myself just sit in the kitchen talking and not offer to help. I gradually went from doing the simple things like washing rice or cutting veggies to learning Uncle Frank's techniques and recipes. Through all the cooking and talking about this and that, I also began to absorb more of the language. Uncle Frank spoke sam yup, and Aunt Susan spoke thlay yip, so that was interesting and fun. The two dialects aren't all that different, but they're different enough. Of course, I also began to pick up on traditions, holidays, celebrations and all that sort of thing.

Uncle Frank and Aunt Susan liked to host the entire family for a big Chinese New Year celebration every year. Over time, and as they got a bit older and slower, I learned enough to make bigger and better contributions to the effort. It really was a lot of fun for me, and of course, the warmth, closeness and joy that I experienced with Uncle Frank and Aunt Susan just meant so much to me. I have carried on their tradition since their passing, and I think I do it as much as an honor to them as I do for the significance of New Year itself. I do love having the family over for it, but I'm getting older myself, so I may only do it for another year or so.

There was still something missing, however. I was gay, and I certainly couldn't go around showing that part of me. I am not in the least bit ashamed of it now, of course, but my upbringing was certainly not what led me to my current conclusions and feelings. Not only had I been an "outlaw" for it, but my own family had ostracized me because of it. I also began to feel less strongly American as I might have at one time. After all, there was my physical appearance. I look fully Chinese. There is no white in me at

all. Furthermore, I couldn't help but resent the type of discrimination and racism that so many of my forbearers had had to endure. One of my uncles used to tell me stories about how Chinatown residents could not step foot beyond the boundaries of their neighborhood. To venture beyond Broadway Street, for example, invited violence, and there was not going to be any police intervention against it.

So who was I and what was I? I needed something. I needed an identity. Being Chinese is what I chose. I look in the mirror and that is absolutely what I am. And I think about my dear Aunt Susan and Uncle Frank. Uncle Frank actually condemned my father's attitudes and behaviors toward me. So, I love them forever, and all that they were to me and all that they showed me that was Chinese is what I have happily chosen to be.

Still, I do not believe in every single thing that is Chinese. I pick and choose. I mainly do what I like and just let what I don't like go. It's time for me to be myself and to do what makes me happy. Take the matter of bai sun, honoring one's ancestors, for example. My parents used to make me do it in the springtime, which was when my birthday is. Imagine, celebrating a child's birthday at a cemetery! Well, I don't do bai sun for anyone except for Aunt Susan and Uncle Frank. And I make sure to bring fresh flowers to them whenever I am in town. They deserve it, and I will love, cherish and honor them in the traditional way until I myself die.

4

EXPECTATIONS AND DISCIPLINE

TO BE BEATEN IS A SIGN OF AFFECTION, TO BE SCOLDED IS A SIGN OF LOVE

*C*hinatown's kids of the 1950s and '60s grew up with a strong respect for authority. Very few ever asked questions. They simply accepted their lot as youngsters who occupied the lowest rungs of the social order. They listened, kept silent and obeyed. At home, authority lay in the hands of parents, grandparents, aunts and uncles and even older siblings. Authority was represented at school by teachers and principals. Whether they were at home or at school, the kids understood that those in authority were endowed with the power to administer corporal punishment. Just because they understood it, of course, did not mean they had to like it. The worst thing for those getting hit was that they sometimes thought that they might die. The best thing was that they never did.

A former Chinatown resident who was a student at Washington Irving and Francisco Junior High recalled his grade-school and junior-high years:

> *If we misbehaved in class at Washington Irving, we could get sent to the principal's office. At Francisco, the teacher saved time and took care of business by himself. At Washington Irving, the routine went along the lines of,*
>
> *Principal: Why are you here?*
> *Student: My teacher sent me.*
> *Principal:* [In a stern tone] *Why did your teacher send you?*
> *Student: Because I was talking…* [eating candy, making faces…]
> *Principal:* [Reaching for a twelve-inch ruler] *Hold out your hand.*

This was in the 1950s, and getting hit in school was just the way it was. It continued up until junior high school and maybe even high school. I remember that at Francisco there was a teacher, I think he was a shop teacher, who had a Traffic Boy stop sign that he used as a paddle. He had holes drilled in it so that it would really move. He usually told a student to bend over so he could hit him, but we thought we could outfox him by stuffing our wallet and paper into our back pockets. Of course it didn't work. He would tell us to take everything out of our back pockets and drop it at our feet. He then ordered us to pick the stuff up. When we bent over to do it, WHAM! He called his paddle the "Peacemaker," and it hurt pretty badly.

I got hit at home, too. So did my brothers and my sisters. All of my cousins got hit, and my friends would tell me about how they or how their brother or sister got hit at home. We never liked it, but it was the way it was back then, and it didn't matter if it was in school or at home.

WORDS OF LOVE

"I'm Ashamed of You"

The same Washington Irving and Francisco student lived on the upper floor of a three-story building. His cousin lived in the ground-floor flat. The former student remembers sitting quietly in his room reading one afternoon. He thought that he might have been in the fourth grade at the time. He was suddenly alarmed to hear the muffled shouts of his uncle from two floors below.

It startled me at first. Then I got really worried because I could tell that my uncle was really mad about something. I got onto the floor and put my ear to it. That's when I could hear really clearly that he was scolding my cousin while also hitting him. My uncle would yell something like, "Why did you disobey me?" Then my cousin would cry out in a way that let me know that my uncle had just hit him really hard. It was pretty scary because my cousin didn't yell out any words. He just made noises like whatever my uncle was using on him really hurt. Then my uncle would yell some more, "You should know better than to disrespect me!" And then my cousin would cry out, and I knew that he had been hit again. Then it was my uncle's turn. "You

should be ashamed! I'm ashamed! I'm ashamed of you!" I recognized the things my uncle was saying as the same things my parents would sometimes yell at me. I stopped listening. When I saw my cousin a day or two later, we didn't say anything about what had happened. I was just relieved to see that he was all right and acting like his usual self.

While growing up, my cousins, my siblings and I would get yelled at and hit from time to time. I can't really remember what I or any of the others did. What I do remember are the things that we had yelled at us. We were never cursed at and we were never called names. Some of the things, including those that my uncle shouted at my cousin that one time, were: "You're not my son/daughter"; "If your grandfather were still alive he would be ashamed to even know you"; "What you did makes me feel like a failure as a parent"; "How do you expect the family to ever be able to count on you?"

I am retired now and live far from Chinatown, but sometimes I still hear these things in my head.

THE TOOLS OF AFFECTION

"Bamboo Sticks, Hot Wheels Tracks, Dark Closets"

It was common for children in Chinatown to be shown painful affection through the creative use of the parental hand or of whatever household items happened to be close by. Walden Jay said: "For small infractions my father had a metal fly swatter handle that he used to swat our hands. It stung like crazy. For more serious beatings they had a big stick like the one from the movie *Walking Tall*[44]…it would leave bruises all over the place."[45]

Gary Kong, who grew up to become a police officer, remembered: "The bamboo sticks that they used to tie a balloon to…probably ¼" in diameter by 24" long…once I got hit with four or five of them rubber banded together, but with one end loose to form a business end that spread out when it made contact.…I almost get misty eyed recalling it…another era of parents with good intentions."[46]

Mel Lim recalled the ear twist, the sharp finger flick to the cheek, the pinch on the forearm or cheek with a sharp twist and "knuckles cracked over the head…it was called ling gok in Chinese and when properly administered, they hurt like the devil. They would say, Gok nay ga how, for, 'it's time for a head bashing.'"[47]

Dabin Lo added: "Hot Wheels tracks…they would leave double welt marks…and they whistled through the air. After a while we threw all the tracks out."[48]

Cooper Chow said: "My mom was more brutal than my dad. She used wooden hangers. And only from the finest stores in downtown San Francisco like I. Magnin and City of Paris. My dad beat us with his soft, open heel, black leather slippers. Although it didn't hurt we were horrified mostly by how he looked as he hit us."[49]

That look by his father as he hit his son was so fixed in Cooper's mind that, years later, he felt compelled to purchase a Japanese Noh mask in its honor. Noh masks are used in Japanese theater and depict the faces of humans or demons. The masks are carved in many styles, and Cooper made it a point to choose one that expressed strong emotions through its agonizingly dilated eyes, flaring nostrils, a deeply furrowed brow and an exaggerated frown.

Several other former Chinatown kids echoed Cooper's memory of clothes hangers but remembered that they were blessed, not with the wooden versions, but with the wire ones, which they were certain hurt more and left more pronounced marks. Others also contend that Cooper missed out on the full slipper treatment, as a true Chinese slipper came equipped with a hard sole that left red marks that would later turn blue with yellowish tinges.

In crowded Chinatown, the sidewalks, alleyways, rooftops and tenement hallways offered play space for kids. *Ken Cathcart Collection. Courtesy of Jim Schein.*

The dreaded gai-mo so (feather duster). Rarely applied to dusting, it was the parental tool of choice for corporal punishment. *By author.*

Jae Jee added: "Oh, the metal towel bar. The bruises from that were terrible, but the slap of Hot Wheels tracks stung the most. I remember the stinging of those tracks way more than the pain of the towel bar. It wasn't like we were bad kids, either. I don't even remember the things we did to get hit. Mom was just so strict. She even admitted later on that she would have been charged with child abuse if anyone had ever gotten a good look at some of my bruises."[50]

Not all discipline was administered by hand, sticks, tracks or footwear. Susi Ming said: "I was always blamed for things that my sister or my father actually did. The chicken feather duster and hairbrush were what my mom used. Worse were the time outs in a tiny dark closet…locked [in] while supposedly waiting for the police. To this day I am extremely claustrophobic. My sister was always amazed that I didn't turn out to be a druggie or a serial killer."[51]

Walden Jay also remembered being confined in darkness in lieu of getting hit: "We had a grocery store that had a large freezer that we didn't use. Sometimes, if the infraction was small enough, we didn't get beat. We just got put in the freezer for from anywhere from twenty minutes to well over an hour. Once the door was closed, not a speck of light or sound could get through. When they opened the door the light and sound were almost overwhelming."[52]

Wanda Wong agreed with Dabin Lo and Jae Jee about the Hot Wheels tracks and brought up a variety of implements of her own: "belt buckles, broom sticks and definitely the feather duster which I never saw used for dusting anything."[53]

A FEATHER DUSTER CASE STUDY

User Innovation from Chinese Mothers

It seems to those who grew up in and around Chinatown that the feather duster, the *gai-mo so*, was ubiquitous in Chinese American households. The dusting head was made up of bundled chicken feathers (*gai-mo*). The feathers were attached to a bamboo handle that measured about twenty-four inches long. User innovation comes about when a product is employed, often creatively and quite effectively, for purposes other than that for which it was originally designed. A great majority of those intimately familiar with it agree with Wanda Wong that the *gai-mo so* was never seen applied to any form of actual house cleaning. A case study of the feather duster concluded this way:

> *The unassuming feather duster is used by most of Western society for dusting. Ah, but the Chinese mother has literally "turned it around"—into the child disciplinary tool of choice. The parent comfortably grips the feathers while whacking the child with the bamboo stick end. I have never seen my mother use the feather duster for dusting…but, I was very well acquainted with the stick end. Many Chinese parents have used the feather duster to the point of bending or breaking the stick while permanently compressing the feathers from their tight grips. My mother must have replaced at least five feather dusters because of me. One replacement was due to my attempt to surgically saw a duster stick just enough so that it would break the next time it was used. Unfortunately, I sawed it all the way through which really upset my mom—leading to a serious beat down after she bought two new feather dusters, always keeping one in reserve for the future.*
>
> *I never liked or understood this user innovation. Nor did I understand the warning that followed to "stop crying, or I'll give you something to cry about." I'm crying because you just beat me with that stick so you're going to beat me some more because I'm crying? Talk about a "vicious circle." Now, of course, my mother as the grandmother of my children admonishes me to never physically punish her grandchildren. "You should always reason with them. They're young. It can hurt them physically and mentally." To which I reply, "Hello! Have we met? Who are you? Don't you remember beating me with that feather duster?" And my mother's final reply would be, "Well, you were a different case."[54]*

This was the preferred method of lighting firecrackers. It came with risk, as stealing mother's incense could later bring out the gai mo so. *Ken Cathcart Collection. Courtesy of Schein and Schein.*

The duster that never dusted. *Photos from franklio. weebly.com/blog.*

The theme of feather duster as weapon was continued by Robert Lowe: "We ran for our lives and hid under the bed as the dread gai-mo so was extended in efforts to strike at us. Just barely out of its reach we thought we were safe in the deep corners beneath the bed. Or so we thought. For then came the end of a broomstick poking and swiping at us. Mom was trying to get us to come out so we could be beaten all the more. At times she really went psycho."[55]

All efforts by Chinatown's youthful residents to break, hide or toss out the *gai-mo so* were futile. The dusters were inexpensive and could be found in practically every store in Chinatown.

Chinatown's Kids as Parents

"My Wife and I Agreed to No Corporal Punishment"

Some of Chinatown's youth who endured physical and mental punishments remain angry or resentful. While they say that they can understand their parents' motives, now-grown Chinatown kids cannot accept what they consider at times unnecessarily intense and harsh beatings. Others, while finding the memories about it still painful, have reasoned that it was done for their own good. Some say that without it, they might not have become good or productive persons. Practically all, however, are firm in their belief that their own children have done well without ever being hit.

Michael Tam said the following:

> *Some kids get it, but growing up, that kid wasn't me…or my siblings. We broke a lot of stuff in the house, blew off our chores and sucked at school. For me, I think a parental reality check every now and again probably wasn't a bad thing. My parents never abused me, but what they did was to*

show me that there were consequences for negative behavior. I don't know for certain where I would be today if my parents weren't strict with me. My two siblings and I all have bachelor's degrees or above and all three of us own our own homes. So, could we have done it without the physical punishments? My siblings and I don't think so. Now, as a father myself, I have never hit my daughters. I didn't have any reason to really…but, of course, they were not like me.

For the old school Chinese there was only the tradition of a firm hand. I'm more flexible with my girls. Nowadays when you take away the cell phone or the spending money you might as well be beating them to death. It's a different generation. I joke around with my parents about it. I say that if I did back then what my girls do now you would have taken the gai-mo so to me right away. And they just play it off like they don't know what I'm talking about. So, no; I never hit my girls. I might scare them a little from time to time but never with anything really physical.[56]

Gary Kong, who also did not employ corporal punishment with his own child, said: "My wife and I decided to no corporal punishment for our daughter. In the Police Academy they TRY to make a distinction between

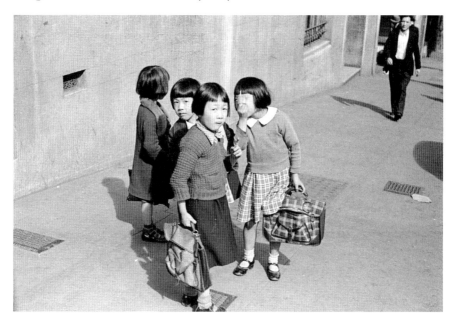

Chinese school students with see-bow holding brushes, ink, calligraphy masters and readers. Good grades kept the gai mo so at bay. *Ken Cathcart Collection. Courtesy of Schein and Schein.*

reasonable parental punishment and abuse. In my opinion, though, it is a very fuzzy line. We punished our daughter when needed, but never physically. She is twenty-one now, going to college, leader of a church group for young adults and working part time. We are both proud and happy that we chose not to use corporal punishment."[57]

Once bruised by flyswatters and sticks that looked like a club that might have been brandished by a tough southern sheriff, Walden Jay is another former Chinatown kid who eschews corporal punishment.

> *I'm just glad that I didn't continue the beatings when I had my kids. After I became a father I realized that it just wasn't necessary to beat the kids for them to turn out great. I'm so much more lenient with my kids than my parents were with me. Sometimes they say stuff and I just tell them, "If I had ever talked that way to my father, I'd be flying without wings." I say it as a joke, but they have no idea how true the statement is. My father had a very low tolerance for anything that he perceived as disrespect from his kids.*
>
> *I'm sorry that my father didn't live long enough to see his grandkids. No matter how often we got punished or beat up I realized as I got older that he was just trying to do his best. Maybe what he did could be considered bad or wrong, but we all have our faults. What hurt the most was that he favored his first-born and last born. My brother and I were in the middle, and we were mostly just tolerated.*[58]

Although he does not elaborate on the specific treatment that he received from his mother, Dan Lee states that she took out many of her frustrations on him. Dan has come to understand in his adult years some of the forces that could have motivated his mother to be unduly harsh with him. Dan says:

> *In 1950 my father returned to China and married my mother in Hong Kong. My mother's parents were salt wholesalers and also owned a cannery and several bakeries and were extremely well off. Her family was prominent and well educated and she was accustomed to privilege and leisure, with nursemaids and servants at her disposal. With the war and then the coming of the Communists, however, the family lost everything.*
>
> *In 1958 my father bought a dry cleaning and laundry business on Clement Street and 4th Avenue in the Richmond District of San Francisco. My parents and I moved from Chinatown into a little two-room shack at the back of the store. The shack had no foundation—the wooden floors*

were laid directly on the top of the sand. My father ran some gas pipes (illegally, of course) from the laundry to the shack so that a small gas heater could be installed in each of the two rooms. Resting atop the heaters was the obligatory metal coffee can half filled with water to provide steamed heat. There was no plumbing; we had to go back into the store to use the bathroom. Between the back of the store and the shack was about eight feet of open space which my father and second oldest brother enclosed and turned into a kitchen.[59]

Dan goes on to say that he had a reasonably well-adjusted and happy childhood. He did well in school and even attended Chinese school through the third grade. He had friends with whom he would bike around the city, swim at the municipal pool and engage in mischief that included "blowing things up with fireworks." He attributes hearing loss in one ear to playing with fireworks. Of his mother, Dan says:

The downside of my childhood was that my mother was not very happy. She worked hard and was thrifty to the end, but the changes that were forced into her life and the hardships she endured as an impoverished immigrant depressed and embittered her. Quite often she took her frustrations out on me. Although I now realize that my mother did the best she could under the circumstances, I still have anger in me that (has) yet to be resolved. My mother passed away a couple of years ago and my father in 1992. I miss him a lot. In time, I hope I will miss her, too.[60]

Robert Lowe, once chased along with his sister under a bed only to be prodded out by a broomstick, says that he has, like Dan Lee, come to understand the circumstances that pushed his mother to treat them so harshly as children. "Thinking back, she was really a very nice person, but she was saddled with being a wife to a gambling husband, being a mother to two kids and having to send money back to relatives in Hong Kong or China. People in Chinatown like my mom were tough; they had to be. I now understand what it might have been to make them snap. I was very resentful of what mom did to us at the time, but over the years, I finally understood. Sadly, that is not the case with my sister."[61]

Robert goes on to say that he believes that his sister's inability to overcome her anger for the beatings she took was exacerbated by the lack of attention or recognition given to her even when she accomplished good things. She had been an excellent student who attended San Francisco's premier high

school, Lowell. That she garnered a 3.85 grade point average was apparently wasted on her parents. Robert does not criticize either his parents or his sister, but he says that he is fully aware of the cultural divisions that had worked into their family: "People like my parents come to a foreign land and the kids that are born to them here are not acting the way they would be if they were back in China. How could they? The old folks think that there is something wrong with their kids. But they lack the language skills to learn and understand about the differences between their old country and their new one. They live with a lot of uncertainty and confusion and they automatically revert to the old ways."[62]

The unquestionable authority of the family was the father. In his absence, that authority passed in full to the mother. Robert feels badly that his sister became so distanced from their mother that she avoided her even as she had reached her final years. He also feels at times that his youthful resentment about how he was treated may as yet not have fully subsided. Through it all, Robert says about the beatings he took at his mother's hand: "I finally understood how my mother had to endure hardships and suffered a hard life, but that can't be blamed on the kids; on us. I know that there had to be some level of discipline, but there could have been limits or restraint. I know that she didn't necessarily mean to be so hard…she had her frustrations. In so many other ways, though, she gave her heart to us, her children. She is now gone, but I want to be clear, I love you Mom."[63]

While it now appears that many American-born Chinese, and even their parents, who were once so quick to raise their hands, have drifted away from the "old country" methods of child rearing, things may still not have changed as much back in China. A recent photo in *National Geographic* of a nine-year-old girl in China was captioned with a quote by her as follows: "Sometimes I secretly help my older brother (on the farm). Mom whacks me when she finds out. She says that girls who do these things will grow calluses on their hands and they become ugly."[64]

WORKING IN THE FAMILY STORE

"I ALWAYS KEPT WEAPONS CLOSE BY"

There were two Chinatowns in the 1950s and '60s. The northern portion was bounded by Broadway and butted against the edge of predominantly Italian North Beach. This portion was a small but self-sustaining Chinese town. It was filled with homes and businesses geared directly toward the neighborhood's residents. The homes on Kearny, Grant, Stockton, Pacific, Jackson, Washington and Clay and in all the numerous alleys springing from those streets were usually cramped apartments. A good many of the dwellings consisted of just a single room or two with shared kitchens and bathrooms down the hall. The businesses included practically everything needed to cater to the everyday needs of the neighborhood. These included a hospital, law offices, dental offices, hardware stores, bookstores, groceries, produce and meat markets, movie theaters, a radio station and more. All carried goods or offered services most suitable to the tastes of an often non-English-speaking southern Chinese population.

The southern end of Chinatown bordered downtown and spread from Sacramento Street down to Bush Street. A number of established non-Chinese businesses occupied some of the area, but there were plenty of small shops and a few restaurants that predominantly catered to the tourist trade. The souvenir shops carried Asian-themed jewelry, clothing and knickknacks alongside postcards and inexpensive novelty items.

A good number of children, boy or girl, spent significant portions of their after-school time, weekends and breaks helping out in a family-run shop. It was rare for any of these businesses to be lucrative. Most did just well

enough to help a family get by. Relatively high rents and tenuous earnings led more than a few families to live in apartments either above or behind the shop itself. In most cases, the working sons and daughters were not paid. The majority of them understood and accepted that they were doing what was needed to help the family out. For their part, the parents were not unreasonable. They willingly provided money for school supplies, lunches and bus fare. Some considered a small payment to be an allowance. Others put their unpaid offspring on the payroll for tax purposes.

HELPING IN THE FAMILY STORE

"I Learned How to Be Self-Sufficient"

Raymond Lee was born and raised in San Francisco. He attended St. Mary's School on Stockton Street, went to high school at Sacred Heart in the city and did his undergraduate studies at San Francisco State. As a child, he felt comfortable within the self-sustaining confines of Chinatown. He could walk just three or four blocks to school. He frequented Chinese Playground or Old St. Mary's Square and the little park behind his family store for outdoor play and exercise. His family did most of their shopping on Stockton Street or Grant Avenue, and they often ordered takeout from the numerous dim sum places and other restaurants nearby. There were even a couple of fully American-style diners offering burgers, fries, shakes and jukebox hits across from each other at Grant and Bush. Until moving away for further study at Wayne State University in Detroit, Raymond helped his family in their Grant Avenue shops. Raymond is currently married and lives in Canada, where he is a faculty member at the University of Manitoba. He remembers his Chinatown days well.

My parents ran the Kuen Luen Company in Chinatown for 25 years. There were actually two separate shops and the first one which opened in 1966 was at 530 Grant Avenue. The second one opened about two or three years later and was at 540 Grant. 530 was a three-story building. The ground floor was the shop itself. We used the middle floor for stock and storage and we had an apartment on the third floor where we lived. 532 Grant Avenue, right between our two shops, was the location of the Shanghai Low restaurant. During its hey-day from the late 1920s until the 1950s the

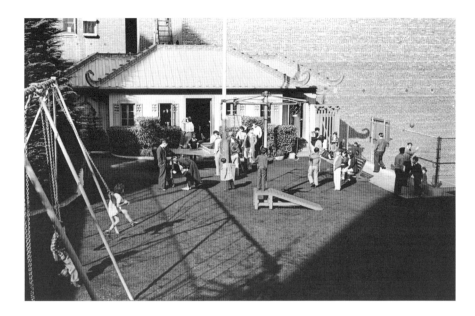

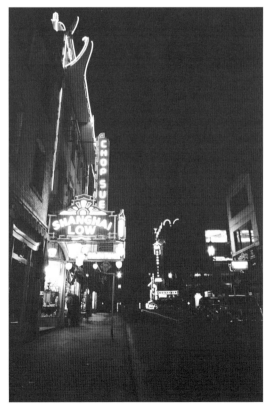

Above: Chinese Playground, renamed for University of San Francisco NIT champion basketball star Willie "Woo-Woo" Wong. About 75 percent of the old lower space is visible. *Ken Cathcart Collection. Courtesy of Schein and Schein.*

Left: One of Chinatown's premier landmark restaurants in its glory days, Shanghai Low. *Ken Cathcart Collection. Courtesy of Schein and Schein.*

owner of Shanghai Low operated both a restaurant and a night club. The club and restaurant, like the Forbidden City which was another popular Chinatown venue of the time, appealed very strongly to a largely white clientele. Their customers thrived on the food, drinks and Chinese dancers that were all the more appealing for the mysterious and exotic reputations that China and the rest of Asia enjoyed.[65]

While the nightclub closed in the early '50s, the restaurant remained in business throughout the time that Raymond's family was at Kuen Luen. Raymond shared some of his memories of their neighbor, Shanghai Low:

I can still smell the delectable aroma of its cooking wafting from the upper floors of the building where it operated. I can also still visualize the patrons in their fine evening attire going up the stairs to the dining room and bar. Mr. Low had operated both the restaurant and a nightclub one block away and across the street at 433 Grant Avenue. When my family had the stores, however, only the restaurant existed. During the busiest times of summer we would order take outs from our neighbor. Whenever I went to pick up the food I would get a good look at the restaurant's deep red carpeting, carved wood furnishings, and cheerfully colored décor. It was all very plush and opulent to my young eyes. By the time our stores closed for good the Shanghai Low location was taken over by Lotus Garden, a Buddhist vegetarian restaurant which has since also gone out of business.[66]

Shanghai Low catered to both Chinese and tourists alike. A few American-style dishes and their prices from one of its 1950s menus included: porterhouse steak ($1.15), rib steak ($0.85), pork chops ($0.65), half fried chicken ($1.25, $2.40 for a whole), club sandwich ($0.50), turkey sandwich ($0.35), mixed green salad ($0.50) and coffee, tea or milk ($0.10).

Of his family's shops Raymond said:

Our shops catered mostly to the tourist trade and in the 1960s and 1970s our merchandise comprised of T-Shirts, postcards, banners, ashtrays and a host of other cheap souvenirs. My father also made batik paintings which he framed for sale. A lot of things were made in Japan back then, but my maternal grandparents lived first in Taiwan and later in Thailand. Through their contacts we were able to import stock that included bamboo brooches, marble vases and wood carvings from Taiwan. We also stocked sterling silver jewelry, bronze Buddha figures and Siamese dolls from Thailand.

This was the site of Kuen Luen Company and Shanghai Low Restaurant. Long gone, both establishments are fondly recalled by Raymond Lee, whose family owned Kuen Luen. *Photo by author.*

The things from Japan included metal ashtrays, origami and lacquerware. During the weeks of summer the main drag [Grant Avenue] was a beehive of activity with throngs of passers-by milling about the gift shops from one end of the street down to the other. In those days Chinatown was a safe place in which to shop, eat or just hang out.

I worked for my father after school and during summers. My duties included dusting and general cleanup, processing incoming stock, keeping shelves filled and tracking inventory. I was also responsible for carrying

Grant Avenue is seen one block beyond its signature entry gate looking toward North Beach and Fisherman's Wharf. *Photo by author.*

our cash register receipts to the Chinatown branch of the Bank of America at Grant and California for deposit. In those days I could carry a brown paper sack full of bills, coins and cancelled checks through the streets with no concern about anything like robbery. I also helped run errands and do grocery shopping in or around Chinatown. In my early teens I was also a salesperson and cashier. I didn't always enjoy these chores, but I did learn about retail operations and how to be self-reliant. I continued to

work at the stores through college and graduate school. Then my younger brother took over.

As rents increased in the 1980s many of the Chinatown stores, my father's included, switched their stock to higher priced items. These included made-to-order necklaces of pearls or semi-precious stones, bracelets and earrings. In the early 1990s, by which time I had my own career outside of San Francisco, ever increasing rents and competition compelled my parents to sell the businesses. Indeed, most of the other old time shops, among them many friends and neighbors, also sold out at about the same time and for the same reasons. They were replaced by business owners from abroad, notably Hong Kong, Taiwan and the Middle East. These new entrepreneurs had money and they brought in a large quantity of higher end merchandise: jewelry, furniture, art and antiques.

I visit San Francisco about once a year and I enjoy visiting my old haunts. On the one hand, I'm glad to see the new shop owners making a go of it even through what are presently some pretty hard economic times. On the other hand, I miss the old neighbors, especially the Low family and their old restaurant.[67]

MAKING NOODLES FOR MY UNCLE

"I Looked Like a Ghost"

The family of one of Darryl Eng's cousins would also, one day, like Raymond Lee's family, operate a Chinatown shop above which they lived. Like Raymond and so many others his age, Darryl's cousin would spend a lot of his school-day afternoons helping out in the shop. Before that, however, Darryl's father was the primary entrepreneur in a family that included some two dozen aunts and uncles along with a further two dozen cousins. Darryl's father owned and operated a noodle factory, a bean-sprout growing and distribution operation and an early version of a Chinese fast-food business. There were many times during a delivery crunch when members of the family could be found helping out in one or another of the businesses. Darryl's cousin recalls a summer when he worked at the noodle factory.

The noodle factory, simply called the mein-chong by everyone in the family, was on Washington Street between Stockton and Grant. It was a small

operation with a narrow front sales area that was separated from the actual noodle-making space by a tall and wide refrigerated display case. There were a few chairs in the sales area, but most walk-in customers would just come in, buy a pound or two of noodles for the day and leave. Family members also stopped by for noodles practically every day. My aunts or uncles would sometimes sit for a while to rest and to chat with one another or with whichever of my cousins happened to be working that day. Sometimes, several family members would be there at the same time, and they would linger to chat about any number of things. Since they all knew how the business worked, they never minded interrupting a conversation to help answer the phone or to make a sale to any shopper who stopped by.

I would report to the shop at about eight in the morning, and one of my cousins or a hired worker would already have the shop opened and ready for the day's business. There were never more than two or three of us there at a time during the noodle-making process. We would start by pouring one hundred pounds of flour into an upright mixer. We then cracked fifteen dozen eggs into a large stainless-steel basin which, once filled, would be poured on top of the flour in the mixer. One-half to three-fourths of a pound of salt and a bit of water would be added, and the mixer would be switched on. We let the mixer run until a lumpy dough of quarter-sized chunks formed. We then scooped basins full of the mix onto a large electrically powered press made up of a feeding tray, two four-foot-long stainless-steel rollers and a receiving tray. One of us would push the lumpy dough down the tilted feed tray. The rollers would squeeze the dough into a rough sheet that would become increasingly better defined with each of the approximately dozen times we would run it through. After each pass through the rollers another of us, standing at the foot of the receiving tray, would dust the resultant mass with corn starch to reduce its stickiness. He would then heave the entire thing back onto the feed tray and whoever was on that end of the machine would use a hand crank to bring the rollers a little closer together for the next pass. The machinery was loud, and there was not much talking among workers.

Once we had the dough looking like a long and doubled-over yoga mat, we would wrestle it onto the feed tray of the adjacent and lookalike press. This was the fine press, and by the time we were done passing the dough through it another dozen times, we would have a long thin sheet doubled many times over that was ready to be sliced into noodles. The slicer looked like a little electric guillotine with a roller cutter at the top instead of a chopping blade. One of us would feed one end of our thin dough sheet into

the moving cutter while someone else used a pair of scissors to precisely cut across the dropping noodles. I never did this, because I did not have the eye to judge just when a pound's worth of noodles had rolled off the cutter. My cousins and the employees were all expert cutters, and they never missed. A couple of quick snips of the scissors followed by a twist of the wrist would produce a neat one-pound ball of noodles. Each of these balls would go onto a wax-papered steel tray. When filled, the tray went into the refrigerated display case all ready for the steady stream of see-nai, Chinatown housewives, who would be in for their daily ration beginning at around ten o'clock. Wonton wraps would also be cut—again, never by me of the unkeen eye and unsteady hand—with precise and perfect swipes of a sharp knife to be placed in one-pound stacks.

Once the noodles and wonton wraps were done, one of us would clean up, one would man the sales counter and the third person would load previously boxed noodles onto a handcart for delivery to the local restaurants. I enjoyed delivering the best. It got me out of the shop and moving around. I would trundle my handcart through Chinatown's streets, dressed in white pants, shirt and apron, my head topped by a white paper hat like those used by bakers, and all the rest of me coated in a film of white dust. I looked like a ghost. Later on, another of my cousins or uncles would stop by with a truck to get the day's out-of-town deliveries. These usually went to Chinese restaurants down 101 and on the Peninsula.

It was heavy work to heave those one-hundred-pound masses and sheets of dough around, but it was fun and I enjoyed the work. It made me feel productive, and I always got a kick of walking into restaurants with my deliveries. It would usually be lunchtime, and the places would all be filled with customers. It was very satisfying to think that I was helping to feed all those people. They always seemed happy as they sat slurping the noodles that I had helped make.

HELPING IN DAD'S JEWELRY SHOP

"He Was an OG Jewelry Guy"

Michael Tam and his family arrived in San Francisco from Hong Kong not long after the 1965 Immigration Act went into effect. Although a relative latecomer to the Chinatown scene, Michael's experiences differ little from

those of his predecessors of the previous twenty years. His family stayed only briefly in Chinatown before moving to another part of the city when Michael was about four years old. Michael has vague memories of staying in an apartment at the corner of Grant Avenue and Broadway when he was a child. Michael originally mistook the name of the building, located at 615 Broadway and built in 1913, as the "Sam Woo Apartments." Michael later realized that it was the Sam Wong Hotel, with many single-occupancy rooms. The hotel's location was ideal for recent arrivals, as it straddled Chinatown's primary shopping streets, Grant Avenue and Stockton Street. It was also right on the edge of North Beach's busy commercial center along Stockton Street and Columbus Avenue. Michael recalls that his mother met and befriended many people from the time when she would make her daily shopping rounds to Grant Avenue and Stockton Street. He still very fondly recalls the *don tot*, custard pastries (*don*, for egg and *tot*, for tart), that she regularly brought back from the Golden Gate Bakery on the 1000 block of Grant. He spoke of his father, the family store and his trips to Chinatown as a teenager and young adult to help his father at work.

My dad owned Paul's Jewelry at 860 Washington Street. He was an OG (Original Gangster) jewelry guy dating back to Hong Kong days.[68] *He started the business in the early 1970s at a time when rents were on the rise and tourism began to decline in the wake of increasing violence related to gang activities. It was tough and it did not help that my dad was getting a little older, too. He stayed in business through it all, though, and closed shop only about five or six years ago in about 2010. I haven't been back since he closed, and my kids have never seen Dad's store. They don't even know what he did; just that he is their Grandpa. It was a humble family business that helped give all three of Dad's kids an education and a good future.*

Dad told me that when he came to Chinatown back in the 1970s there wasn't a lot of people selling jewelry. He said he used to be a wholesale travelling merchant who went store to store in Chinatown with his stock. He got tired of doing that and settled down to make a go of it in his own shop. He was one of those guys who could tell real stuff from the fake by just looking at it. He also repaired and made his own original jewelry. Not too many people in the jewelry business in Chinatown could have claimed to be able to do what Dad could. Most of the people who sold jewelry never made their own and some couldn't even judge quality or real from fake. They simply relied on whatever a wholesaler would tell them. Dad knew diamonds by cut and quality and he recognized all types and grades of jade

for exactly what it was. This was at a time when almost every store labelled cheap soapstone pieces that, at a glance look quite good, as jade.

I miss the old neighborhood. I miss getting a Vietnamese sandwich from the Little Paris and a coffee for Dad plus the mung bean Mochi stuff.[69] And the dim sum to go place next door where five dollars of dim sum would stuff me up more than what I could get at McDonald's for that same five bucks. If I got ten dollars' worth of dim sum there was no way we could possibly finish it all. I also miss the St. Mary's Chinese School, the YMCA swimming pool, and the YWCA weekend Chinese school. I really enjoyed getting cigarettes for Dad from the nearby Chinese run mini-mart, too.

Dad never wanted me to stay in Chinatown. I don't blame him. The gang activity was at its worst in the 1980s. He just thought that there was a better world for us outside of Chinatown. And he was right. But we all still miss those days. And, yes, I hated with a passion sitting at the store to help out with my parents because that meant that I couldn't go out and have fun, but there was a lot of compensation for me at the Little Paris and the dim sum place.

I have lots of good Chinatown memories, but boy, things have changed so much that I don't even go back any more. I don't think Dad does either. The guy gave all he could, but at more than seventy years old, less than perfect health, and constantly rising rents, he just couldn't do it anymore. After a while he wasn't even making any money. We basically had to pull him out of that place. His last couple of years was just a donation to the community because he was losing money every month. It's sad that someone like him, one of the OG jewelry guys that knew everything about the business dating all the way back to his Hong Kong days would end up going out like that. And yeah, he and my mom knew everyone back then. They really gave everything they had to that business…and to us.[70]

Growing Bean Sprouts

"We Would Blow the Beans at Each Other through a Straw"

Along with his noodle factory and takeout or delivery food service, Darryl Eng's father owned a bean sprout operation. It was not a large business, and like with his other enterprises, most of the family—young and old—invariably wound up pitching in at one time or another. One of Darryl's

cousins remembers the time when his mother lost her wedding ring inside a twenty-pound sack of sprouts sometime while she was hand packing it for delivery. The problem was that there were at least a dozen such sacks already loaded onto the delivery truck before she missed her ring. There was more than a little panic as aunts, uncles and cousins all dashed for the truck. The sealed bags were removed one by one to be opened and sifted through. Fortunately, only a few sacks needed opening before the ring was found. The business was relatively successful; it lasted until well after Darryl had grown up and moved away. He recalls it from his childhood days:

The place where we grew the bean sprouts was on the ground floor of a dark and damp brick building. It was more like a basement, and it always smelled musty. At one end there was a big walk-in refrigerator for storing packed bean sprouts. When my brother, a cousin who lived nearby and I were like eight or ten years old, the three of us would go in and see who could last the longest in the cold. There was no danger of getting stuck, because there was a large metal button that you pushed to get out. Like a regular refrigerator, the light went out when the door was closed. We would stand there in the cold and the dark. We usually didn't last too long, because we would either get psyched out and just open the door or one of the adults would open it and yell at us.

We also liked to hang out on the floor above. It had just a small window, so it was always dim. There was nothing up there except one-hundred-pound bags of dried mung beans stacked almost to the ceiling. We liked to climb on these and pretend that we were defending a fort against hordes of marauding Indians who were, of course, invisible. We also liked to lay on the top layer of sacks, the burlap of the bags making our backs itch, to read comic books despite the dire warnings of our various aunts that we would ruin our eyes. We were usually mindful of adult admonitions like that, so we would take breaks from reading to just talk or to invent some kind of game to play.

We would sometimes pretend that our stack of filled sacks was a spaceship to Mars, or a battleship or a desert island. The dangers we invented needed defense, so we would pinch a little opening in one of the sacks, draw out a handful of little green beans and pop them into a straw that served as a blowgun. Since our Martians, Indians, stampeding herd of elephants or other adversaries were invisible, we usually turned our attention to ourselves. We would blow beans through a straw at each other. Many times, our play would be interrupted by an invitation to go on delivery

rounds. We would eagerly scramble downstairs, help load bagged sprouts onto the delivery truck and hop aboard behind the last one. Sometimes, we would have the job of sitting against the bags to keep them from flopping over from the truck's motion. One uncle who did regular deliveries was a World War II veteran who would tell us war stories. Another let us crank the radio volume all the way up, and we would sing along with the top forty hits or listen to a Giants game and sing along with the commercials. These delivery rounds often ended up with soft drinks or ice cream.[71]

The sprout-production process was all done by hand. A one-hundred-pound sack of dried mung beans would be poured into a cement mixer with water for washing. When clean, the beans were put in fifty-gallon metal containers with warm water to start the growing process. After about four hours, the green shells of the beans would be expanding and cracking. They were scooped up and put into wooden barrels. Each barrel would be covered by an empty burlap bean sack, watered every four hours and left standing in the cool darkness of the growing area. Growth would be optimal after about five or six days, and the sprouts would be removed, washed, dried and packaged into five-, ten- or twenty-pound sacks for sale or delivery.

Another Family Store

"I Always Kept Weapons Close By"

Leland Wong, born in San Francisco, was another young Chinatown resident in the 1950s and '60s. His father owned the Fueng Wah Company, located at 625 Grant Avenue. The family lived above the shop, and Leland could often be found working in it alongside his father. Leland remembers his old neighborhood:

Since our store was only two doors up from the Far East Café we got take-out from there often. Our favorite was Ahp-Gueng-Yee-Mein, or soup noodles with duck. During the summer months when we stayed open until midnight my parents sent me for chow mein from Kay Kay Garden on Washington Street. And right across the street from the store there was a place called the Lotus Bowl and my father would go there to take a break and yum-cha *(have tea and dim sum). They served other food, too; chow*

mein, meatless dishes, chop suey, eggs, rice, Canton style chicken, chow yuk, sandwiches and a lot more. It was a real mix of Chinese, Chinese-American and American.

I knew a lot of people from around the 600 through the 400 blocks of Grant Avenue. Even if we didn't necessarily socialize, we did a lot of the same things and went to a lot of the same nearby places on errands. I remember Calvin Louie and his brothers who were on the 500 block. I am still friends with Calvin. Then there was this guy named Paul who had a pretty big family. I think his family still owns the building in that little alley just behind Grant. There was Andy Der whose family owned a store right on the corner of California Street. He had two sisters, too. Randy Low who was a bit of a fei-doi (fat kid) was the son of the Shanghai Low restaurant family. He was in my Cub Scout Troop; Troop 219. He went to school with us at Commodore. And there was a bad boy named Gary, and I think that he lived in the same alley as Paul. Gary was a real bully who would beat up on other kids at the Chinese Playground. His brother who wasn't much better snatched my toy sun exposure camera right out of my hands once. That was on California Street.

Thinking of California Street for bad things that happened to me; I remember getting hit by a car at the corner of it with Grant. I was eleven years old and I had just hopped off a cable car. Further down Grant, on the right hand side going towards downtown was a funky smelling store that had a big display of kimonos out front. Whenever you walked by it gave off a really strong lived-in odor. I don't know how they made any business. Anyhow, one of my classmates at Commodore named Susan lived there. There were several sisters and one of them practiced piano. You could hear her from the street. She was pretty good. Later Susan changed her name to Suki. I remember Susan's store because I sometimes went right past it to go to Burger Town right on the corner of Grant and Bush. It was a narrow place, but well lit. The grill went all along one wall and a counter separated it from the rest of the place. You either got take out—burger, fries, shakes; what else?—or you sat at the counter. There was a big jukebox against the narrow wall to the far end, too. Around the corner there was a grocery store. The family was from Hawaii and they sold what they called "Honolulu Egg Sandwiches." They were just egg salad and there was nothing that special about them. A lot of the people I knew went to both the burger place and the grocery store.[72]

The Chinatown cable car brought tourists and much-needed business to Chinatown. Many Chinatown kids took cable cars to school for a nickel a ride. *Photo by author.*

According to Leland, working in a Chinatown shop was not always the simplest or the easiest thing to do.

> *You really had to keep an eye on the shop if you didn't want to get ripped off blind.* Hau-yeh, *or stealing things, was what we called it in Chinese. We had a balcony, we called it the* na-yeh, *over the sales floor and I used to stand on it to watch for shoplifters. I have caught many of them. We usually just grabbed the stuff back and let them go. Most likely they would just move on to the next place and start stealing again. The worst was when they came in groups. There would be a few who would distract us while the others stole things. They were mostly groups from outside of Chinatown; blacks and Latinos. One time, though, a Chinese-American gang, the Immortals, came into the store. They were small time; just a group of guys trying to be tough. I even knew some of them at school and I wound up catching one of them, his name was Lester Tom, in the act. Some of those shoplifters who came in groups could get pretty violent. My father got punched in the mouth one time and bled pretty badly from it. There were many situations where I nearly got into a fight, too. After one particular close call with a bunch of Latino kids I took it upon myself to begin learning martial arts. I always kept weapons close by. We had nunchakus well before they became all the rage because of how Bruce Lee used them in his movies.[73]*

99

Leland remembered some of the stock items that Fueng Wah Company carried:

Immediately after the Communist takeover of China in 1949 the US government reacted by enforcing a trade embargo against the country. Throughout the 1950s and 1960s all of the Chinatown shops resorted to carrying goods that were made in Japan. Naturally many of the salesmen that came into our shop were Japanese and since post-war Japan produced a lot of inexpensive curios, they were what we made most of our sales on. I remember wind-up cars that were made from reused tin cans. Sometimes when you looked under or into that kind of Japanese made toy you could actually see original painted labels like "Swift Ham" or "Folger's Coffee." We also carried Happi coats, kimonos, painted scrolls and ceramic figurines of things like Kuan-Yin (a mythological figure), Foo-gow (another mythological figure that was half lion and half dog) or Asian looking horses. All of it came from Japan. I once caught a white lady trying to make off with one of those cheap ceramics. Any Chinese goods that we got, and it was not very much, were smuggled in through Hong Kong. During the shipping stopover the merchandise would have "Made in Hong Kong" stickers placed onto it.[74]

Leland recalls some of the oddities carried by Fueng Wah. They sold for anywhere between twenty-five and ninety-nine cents. While these items were surprisingly popular, they seldom had anything to do with Chinese (or even Japanese) art, history or culture. Nonetheless, these were the things that helped produce the revenues and slim profit margins that allowed Chinatown's shop owners and their families to survive.

There was the "Patent Alarm Clock Candle." It was nothing more than a wax candle with regularly spaced markings supposedly set apart at one hour intervals. The candle alarm was to be inserted into the user's hind end at bedtime. There was also fake dog poop, rubber barf, Whoopi-cushions and ashtrays sculpted in the shape of a hand with its middle finger extended. These gag gifts were all made in the USA and I think that I may have gotten my sense of humor from being surrounded by them day in and day out. My father also came up with the idea of using brush and ink to write people's names in Chinese for a quarter. He usually did this by converting the English sounds of the name into

Popular tourist items. Ceramic Kuan Yin (Goddess of Mercy) and Buddha figurines sold very well. *Ken Cathcart Collection. Courtesy of Schein and Schein.*

their closest phonetic equivalent in Chinese. Then he could come up with reasonably appropriate characters. He was the only Chinatown shop owner to do that name thing and it even got a write-up in Herb Caen's column.[75]

I loved the idea of living above the store because I could just roll out of bed and quickly be at work. I suppose it was like growing up on a farm. You lived and did everything where you worked. Another positive thing about working in the shop was that my friends would often stop by and we would enjoy ourselves just hanging out. I had a sense of being self-employed and I liked the freedom associated with it. Maybe that's why I've been self-employed practically all my life. Today I am an independent artist and photographer. I was surrounded by Japanese art goods at Fueng Wah, so I now realize just how much influence those designs and colors had on me and the artwork that I produce. My father also had an artistic bent, so I may well have inherited that part of him.[76]

RESPONSIBILITY AT THIRTEEN YEARS OF AGE

"They Left Me Behind to Look After the Bakery"

Nelson Wong was born at the Chinese Hospital in October 1948. Like so many other Chinatown baby boomers, he was delivered by Dr. Helen Chinn. Nelson's father had come to San Francisco in 1939 as an eighteen-year-old paper son. Nelson lived with his parents and three siblings in a mixed-use building on the 1100 block of Stockton Street. He recalls that the ground floor of the building was occupied by a noodle factory; the upper floors contained small residential apartments.

According to Nelson, his family occupied a small two-room unit that lacked hot water. Bathroom needs were taken down the hall to a communal toilet. Nelson remembers washing in the family apartment by means of sponge baths in a basin with the hot water being heated on the stove. Nelson did not find such conditions particularly unusual, as all of his neighbors lived in the same fashion. The Stockton Street apartments were occupied

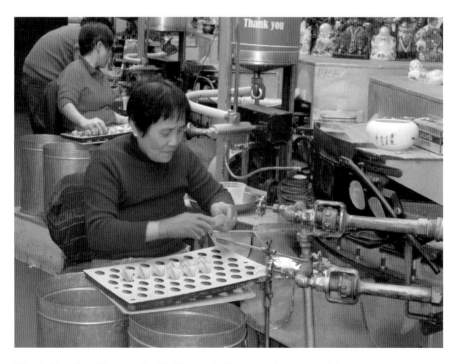

The Golden Gate Fortune Cookie Factory in Ross Alley is the last of its kind in Chinatown. *Photo by author.*

by families who spoke a variety of dialects of Chinese. These were often mutually understandable enough for people to communicate, help each other out and grow close to one another.

Nelson's family eventually moved to an alley just off of upper Grant Avenue in North Beach. By the time he was a student at Francisco Junior High School, he was helping out in the family business. Nelson remembers:

> *In the early 1950s my father opened the Mee Mee Fortune Cookie Bakery on Stockton Street. My mom worked first as a seamstress and later joined my father at the bakery. Because it was a family business we kids spent a lot of time at the bakery helping out especially during the summer months. There was no such thing as summer vacations. I accompanied my father on deliveries to such establishments as Trader Vic's Restaurant, Woolworth's and Macy's in downtown. I knew my way around the back alleys of Chinatown and the back entrances of restaurants.*
>
> *One defining moment for me was when I was about 13 years old and my paternal grandfather passed away in Canada. My father, mother and younger siblings traveled to Canada to make funeral arrangements leaving me behind to look after the bakery. I went to the bakery after school, prepared the cookie batter for the following day and closed up shop in the evenings. I was never so scared in my entire life. I was afraid of making a mistake with the batter. After all, we are talking about huge batches that contained hundreds of pounds of ingredients. I was glad when they came home after about a week. Sometimes I wonder if my parents did the right thing in leaving me with such heavy responsibilities, but that experience did teach me how to accept challenges and to be responsible.[77]*

6

HOME COOKING, RESTAURANTS
AND TAKEOUT

GREAT MEMORIES OF YUMMY FOOD AND LOVE

*L*ate hours at work might not have allowed every family member to be present for the evening meal, but in Chinatown, the call to dinner was the time of family togetherness. Whether the meal was taken in relative silence as mandated by the father or if it was fairly open with kids and adults chattering away simultaneously, there was a feeling of family unity at the table. The sense of community was heightened by the fact that food was shared. Dishes were set in the middle of the table, and diners reached for what they wanted when they wanted it. Sometimes, a family member would use his or her chopsticks to helpfully place something onto another's plate or rice bowl. It was face-to-face time, and nobody read a newspaper or listened to a radio or tried to sneak a peek at the TV. The TV or radio would have been turned off, anyway.

A FEW OF OUR LEAST FAVORITE THINGS

Green Milk and White Gobs

Growing up, each Chinatown baby boomer had food that was his or her favorite. There were also those items that were less than favorites. The list of what the Chinatown boomers did not enjoy eating, while not extensive, reflects the general childhood aversion to vegetables. One such out-of-favor vegetable (although not true for everyone) was *foo gwa*, the bitter melon.

Standby dishes continue to warm the hearts of old Chinatown kids to the present day. *Photo by author.*

The foo gwa is roughly the size and shape of a cucumber, but it is a much brighter green, and the thick and waxy outer skin is wrinkled or ridged. It was most frequently slit open, scraped clean of seeds and sectioned to be stir-fried or made into soup. Melody Chan Doss-Wambeke, who grew up at the foot of Telegraph Hill in North Beach, still shudders a bit when recalling the melon's taste: "Of course, our least favorite dish was probably the healthiest one for us: sautéed bitter melon! Mom made it often with beef and black bean sauce. The sauce helped a lot, but no matter how it was cooked it always lived up to its name and stayed bitter!"[78]

Jack Woo, a retired pharmacist, stated:

My least favorite food as a kid was bitter melon. Gradually, though, as I got older it became my favorite. I guess it was because Mom just kept cooking it and I somehow developed a taste for it. Now I always order it when I visit Chinatown. Another favorite when I was a kid was cow brains in soup. I don't eat it anymore, though. Cholesterol! My go to comfort food during high school and college was hom-yue gee-yuk beng. It's made by mincing a piece of pork butt with a cleaver, spreading it as a thin patty onto a platter,

105

placing some dried salt fish in the middle of the diced meat and steaming it all. Put it over rice and…yummmmm…it really gets your appetite going.[79]

Many who eat bitter melon agree with Jack and say that it is an acquired taste.

While none has nearly as strong a taste as foo gwa, the following have a place on the childhood list of least favorites: broccoli, green beans, spinach and various Chinese *choy*, or green leafy vegetables.

While saying nothing about his own preferences, a former schoolteacher remembered a childhood episode involving his younger brother and some stir-fried *gai lan choy*. Although it is a leafy green, it is sometimes called "Chinese broccoli," because its flavor is supposedly similar to that of broccoli.

My brother was about six years old at the time, and we were at the dinner table. Dad was at work, so it was me, my brother and sister and my mother. The rule was that we were all to stay at the table until everyone was finished. Usually it wasn't a problem. Well, that night, my brother decided that he just didn't like stir-fried gai lan choy and refused to eat it. My mother gave him the spiel that, until he did, we would just sit at the table and wait.

My brother picked some of the gai lan up and dipped it into his milk. My mother said that she didn't care what he did with it; he was still going to have to eat it. I was irritated because I wanted to go watch TV, but the sight of my brother's milk turning green made me laugh. That made my mother snap at me to be still. My brother continued to hand dip his gai lan choy into his milk. Our mother glared at him and said that he was also going to have to drink all his milk as well. My brother continued dipping and dunking his gai lan. Green-tinged milk was splattering all over the table. Finally, our mother decided that enough was enough, and she started shoving soppy gai lan into my brother's mouth and holding her hand against his lips so that he had to swallow. I was bursting with laughter, and my eyes were so watery that I couldn't see. Finally, my mother said that she had had enough and we should all just get out of her sight.

A graduate of Galileo High and former special education teacher remembers her moments with a food that she found to be less than savory: "I remember the only food that I could not eat as a kid was these white gobs of flour in a soup. I'm not quite sure what you call them! We had them once at my grandma's with my cousins. We couldn't chew them and we couldn't swallow them whole. Spitting them out would have been gross and someone

might come by to make us eat them anyhow. So we tossed them out the window. Needless to say the street outside grandma's apartment was covered with all these big white splotches that we thought looked a lot like giant pigeon droppings!"[80]

Girls Just Want to Have Fun

"I Got Some to Stick on the Ceiling"

Some may find a dislike for *bok choy* surprising, since the leafy green has found its way to popularity in many stores and markets across America.

Once disdainful of her veggies, Nanette Lim said: "I chewed my bok choy, but I couldn't swallow it. I would spit it out and play with it. Then I would try to see how high I could toss it. I got some to stick on the ceiling. This was when I was in early grade school."[81]

In another case of "I just know what I like and what I don't like," another now-grown Chinatown girl agreed with Nanette: "*Bok choy* was the worst!" She recalled that it was served often and remembered gagging on it as she was forced to swallow it, anyway.

For the most part, Chinatown seafood dishes, whether cooked commercially or at home, are well prepared, nutritious, tasty and well liked. As with any food, however, not everyone living in Chinatown found fish or other table fare taken from a watery habitat completely enjoyable. Among Chinatown's food for sale were snails. These could usually be found in pans of water set out on the sidewalk. They have been characterized as rubbery in texture and a bit spicy in taste.

One woman recalls an adolescent misadventure with the little mollusks that were called *teen law*. They were often served at her father's family association. As a child, she and her friends used to have races to see who could eat the most the fastest. She stated that she once competitively slurped them "until I puked." She added that, from that point onward, she lost her taste for teen law. An acquaintance recalled the unhappy experience of slurping on a snail, only to get a mouthful of teeny little shells. She, too, lost her taste for teen law.

Another girlhood memory comes from Marilyn King: "I never had a least favorite dish, but the weirdest thing I ever tried to do was unsuccessfully try to smash a fish's eyeball. My mom told me to stop because some people like to eat it."[82]

MORE ON THE WHITE GOBS

"They Were Hard to Chew and
They Had a Texture I Can't Describe"

The mystery gobs such as those once tossed out of grandma's window were subsequently identified by a one-time Chinatown resident who once helped his mother prepare them.

> *The white gob stuff was called tong yuen. It was pureed sweet rice that was then drained dry in a porous sack. I remember forming the little balls when I was little. It was a winter item that my mom made with chicken broth, turnip slivers and dried shrimp. She topped the broth off with scallions and parsley. You can also make the sweet version of it with melted down Chinese rock candy.*
>
> *Us Boomers need to learn the old recipes and hand them down to our kids. Otherwise they and all these stories will just be lost.*[83]

Tong yuen is a type of *mochi*, a Japanese rice ball that has existed since the pre-Christian era. Among the Chinese of more recent times, it is eaten on the first day of winter as a symbolic means of keeping the body warm. The handmade gobs or balls are dropped into hot chicken broth to be fully cooked. The size of each of the balls depends on the preference of the person making them. Dislike for the little white balls has not been limited to childhood.

One-time state employee Darryl Eng said: "I remember eating some recently that were the size of a meatball. Each one took up the entire space of a Chinese soup spoon. They were pretty hard to chew and they had a texture that I can't really describe. All I can say is that I didn't like them as a kid and I don't like them now. They're pretty hard to swallow. We called them 'yawn,' for 'round thing[s].'"[84]

Having grown up as a second-generation ABC whose parents were not much into the more traditional Chinese foods, JuJu Lee recalled her first experience with tong yuen as a newlywed: "About those gobs of flour; my parents were born here, so I never had them. Newly married…I went over to my in-laws and my mother-in-law says, 'Try this; it's yummy!' I put it in my mouth and could not swallow that dough ball. Despite wanting to impress my mother-in-law, I had to spit it out into a napkin while she was not looking. I then fished all the others out of my soup to slyly drop into my hubby's bowl. The soup by itself was fine."[85]

Irene Dea Collier, who learned to cook at an early age by her mother's side, offered an explanation of the yawn or tong yuen as best she knew:

The yawn are a traditional thing for the winter solstice. The date is never exact, but it's usually on the twenty-first, twenty-second or twenty-third of December. They are specifically round, because the shape is symbolic of unity. You're supposed to gather as a family and eat them together. There are all kinds of variations; some are colored, others have bits of filling in them and some are sweetened. There are also different ways you can eat them; singly, as many as you want or a big one followed by some small ones. Chinese history and culture are so long and so diverse that I don't think there is much in the way of specific rules for yawn anymore. The date is important, and sharing with family is important, but I just keep things simple and make the basic village version that my mother did.[86]

SOME ENDURING FAVORITES

"Great Memories of Love and Yummy Food"

Large numbers of those who grew up in Chinatown during the 1950s and '60s will swear that there is nothing in the way of food that they did not like. As adults, they now claim that it was all good but are usually hard-pressed to name any specific favorite. Nonetheless, when asked, memories do not take long to conjure up dishes and foods such as mom's or grandma's *joong* that more than one ABC has called a "Chinese burrito," homemade rice noodles called *fun*, New Year's Monk food called *jai* and much more.

Sophia Wong remembered the wide, flat rice noodle rolls of her youth: "My favorite as a kid was the steamed *cheung fun* that my grandmother made from scratch. She would liquefy water soaked rice in the blender and then let the resulting rice liquid slow drip into a bowl. She would then pour a thin layer of it onto an old pie pan and add beef filling (to steam). Great memories of love and yummy food. We kids would all sit in the kitchen and wait for the cheung fun. Oh! My least favorite thing was probably plain tong yuen."[87]

Grandma's jai, prepared to be eaten together with one's extended family at the start of the Lunar New Year celebration, has also been fondly remembered. While the homemade versions will always be held most firmly

in the hearts of those who grew up in Chinatown, the dish has gained popularity and can now be readily found in Chinese vegetarian restaurants.

The name *jai* is derived from shortening the dish's name *lohan jai*, which means "Buddha's delight." Since it has been around for a long time and because not every one of the many traditional ingredients is always available, there are many versions of the dish. According to several modern-day chefs:

Eating jai on the first day of the New Year symbolizes purification of the body. In general the ingredients represent good luck. Some have specific attributes. Several such as the black fungus (fat choy), lily buds (jinzhen), and gingko nuts (bai guo) all symbolize wealth as well as good fortune. Additional blessings come from the vegetarian nature of the dish. Since not killing animals is a good deed, the kindness is rewarded by good fortune. Using knives, a tool often used to kill for food on the first day of the New Year, is bad luck. Jai which involves a reasonable amount of cutting or slicing must be prepared beforehand during the old year. It is also a requisite to take extra care not to drop loose ingredients onto the floor while preparing jai unless the plan is not to clean them up. Sweeping a floor on the first day of the New Year is equivalent to sweeping out all of a house's good fortune.[88]

Lifetime San Francisco resident Melody Chan Doss-Wambeke remembered a favorite that her mother made: *joong* (also pronounced and spelled *doong*). Joong are quantities of rice blended with a variety of ingredients, wrapped in lotus leaves formed into a squarish shape with sharp corners, held together by string and steamed.

My favorite was my mother's joong. I recall that she spent days combining glutinous sticky rice with finely diced Chinese sausage (lop cheung), *salt pork, peanuts, dried shrimp, and other Chinese ingredients that she wrapped in dried leaves (which were sold in long strips in Chinatown produce shops for their specific use as joong wraps). She would make about 40 or 50 of them at a time to distribute to family and friends in the early summer. Of course she had her own secret family ingredients that she added. I have tasted joong from restaurants but they never taste like my mother's version.*[89]

In some instances, one-time Chinatown kids have tried to make their own versions of a favorite dish that they could no longer find. One difficult-to-locate dish if one lives where there are few other Chinese is Peking duck.

A sampling of favorites once handmade by mom or grandma: joong, dumplings and cheung fun. *Photo by author.*

Joong: sticky rice, meats, nuts and flavorings wrapped in lotus leaves. *Photo by author.*

Cookbooks stipulate that the main ingredient be "one fresh whole duck from Chinese Market or poultry shop." If one is not in a Chinatown, the more realistic option would seem to be "one frozen duck encased in plastic wrap from Kroger or Safeway" followed by the principal instruction, "Allow to thaw."

One Peking duck lover who relocated to the Midwest missed it so badly that he persuaded his teenaged daughter to collaborate with him on an effort to cook their own. They started with a solidly frozen supermarket bird imported from Canada.

> *The recipe didn't look particularly complicated. The main trick, I thought, was to try to be as authentic as possible. We first had to hang the duck to dry in the open air breezes. That really wasn't so hard; I just put a little noose around the stub of the thawed duck's neck and let it dangle from a conveniently placed hook under the eaves of my roof. When I sent my daughter to check on it an hour or so into the process, she dashed into the house screaming that it was covered by flies. Sure enough, when I looked, all I could see was a jiggling mass of black slowly twisting at the end of*

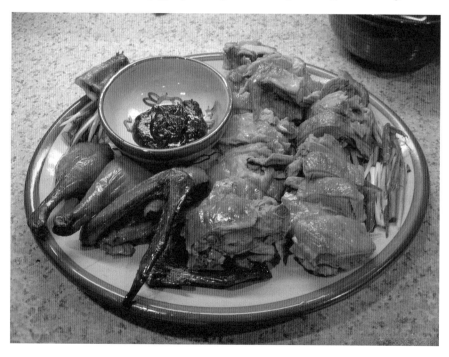

Whole Peking duck made at home and served with hoisin sauce. *Photo by author.*

its tether. Not wanting to waste a seven-dollar duck, we shooed and brushed the flies away, brought the duck into the kitchen and rinsed it off. We then took it to the basement, reattached it to a joist and put an oscillating fan nearby. We placed a pan underneath the bird to catch any drippings. There wasn't any sense inviting roaches or ants. It worked fine, and not a single fly bothered our duck.

Later, while the duck roasted, my daughter took on the task of making the thousand-layer buns that are eaten with it. A large part of the success of the buns comes from the technique more than from the recipe. Whatever recipe she followed worked out very well, as the buns were white, warm, moist and fluffy.

CHINESE RESTAURANTS

Good, Cheap, Fast and Portals for Immigration

A Chinese chef recently interviewed on television asked why French cuisine, but not any Chinese equivalent, could often command premium pricing at upscale restaurants. The answer might lie in the fact that, from its earliest origins in the United States, Chinese cooking was not designed to be haute cuisine so much as everyday fare for the common person. A majority of the Chinese immigrants in the nineteenth and early twentieth centuries in America were bachelor laborers. Strict immigration restrictions barred Chinese women from entry to the United States. The men worked long and hard hours and, lacking wives who might normally prepare meals for them, resorted to either making their own meals or paying other bachelors to cook for them. The men gradually forged homes in the overcrowded neighborhoods to which they were restricted. With time, these isolated enclaves evolved into self-sufficient communities that included inexpensive and basic eateries. The larger and more vibrant of these communities grew into Chinatowns. The pre–World War II Chinatowns of large cities like San Francisco, Los Angeles, New York and Chicago and in smaller cities throughout the country were not long in being discovered by mostly young and adventurous Americans. These non-Chinese were especially attracted to the inexpensive, exotic, tasty and efficiently prepared Chinatown dishes. They appear to have established the standards by which commercial Chinese food is now generally judged.

One of the reasons there are so many Chinese restaurants, whether in Chinatown, the suburbs or shopping malls and plazas, goes back to the former immigration restrictions placed on Chinese. One of the loopholes in the laws of exclusion was created in 1915. It granted special immigration privileges for merchants. Owners of businesses including export-import firms, laundries and restaurants could later sponsor relatives back in China for legal entry into the United States. In the case of restaurants, there were restrictions that served to block "hole-in-the-wall" or makeshift operations that would only nominally be recognized as restaurants. An aspiring restaurant owner/operator would be granted merchant status only if his establishment could meet specific guidelines defining it as a "high grade" restaurant. These rules, designed to prevent a massive flow of individuals claiming to be restaurateurs, were less than foolproof, and many Chinese found ways around them.

Groups of hopeful immigrants back in China would pool money and send one of the investors or partners to lay the groundwork of setting up a restaurant that met the "high grade" requirement. Over the course of time, each investor-partner would take turns as manager or operator of the business and thereby earn full merchant status. The restaurants could not operate in a vacuum, of course, and they would all eventually establish networks with non-Chinese businesses that ranged from restaurant equipment suppliers to food vendors. The white connections of the Chinese business owners would, as much for the benefit of their own businesses as for the needs of the Chinese, often testify to immigration officials as character witnesses on behalf of hopeful immigrants.

Chinatown's restaurants served to stimulate the economies of both Toishan in China and in San Francisco and the Bay Area. A fair portion of money earned through restaurant operations was sent back to the villages. It helped to supplement family incomes back in the old country and was often put to use for improvements to the villages in the form of schools, roads or water-distribution systems. Nearer to Chinatown, money made its way into city and county tax coffers as well as onto the ledgers of ancillary businesses in the form of black ink.

In San Francisco of the 1950s and '60s, there were essentially two types of Chinatown restaurants. Those like Johnny Kan's on the Grant Avenue thoroughfare catered to tourists and celebrities. Locals would usually frequent places like Kan's only for special occasions like a wedding or a red egg and ginger celebration that called for a banquet. The everyday eateries that took care of the average Chinatown resident

were spotted throughout the neighborhood's streets and miscellaneous alleys. These were the humbler restaurants that offered modest meals at equally modest prices. Some of the places favored by the locals also hoped to attract tourist dollars. These restaurants and cafés featured standard menus that offered dishes designed to appear to be Chinese for the non-Chinese palate. Stapled to or tucked within these menus would be a mimeographed sheet written in Chinese characters with the day's real Chinese food.

A Place for the Old-Timers

Their Roast Pork Melts in Your Mouth

The New Lun Ting Café at 670 Jackson Street sits directly across Beckett Alley from Red's Place. Red's, a bar, and the New Lun Ting, commonly called the Pork Chop House by Chinatown old-timers, are neighborhood landmarks. Longtime residents recognize the two businesses as always having been a part of the community. They are a part of a fading era. In the face of economic and social change, these are the types of places that the Chinatown Community Development Center would like to see preserved. Both have been designated as San Francisco legacy businesses: long-established institutions that contribute to the history and culture of their neighborhood.

CCDC executive director Norman Fong is a regular at the Pork Chop House. Of it, he says:

> *Chinatown was once a bachelor society, a condition brought about by the 1882 Chinese Exclusion Act. Restaurants catered to those single men who were more likely to eat alone than to gather in large family groups at a banquet table. The Pork Chop House is one of the last of that kind of place. Its roast pork brings back memories of food that I can still enjoy today. Their roast pork melts in your mouth. It might cost a fortune somewhere else, but it's really good old Chinatown food. And it's been the exact same since I was a kid, and no one knows the secret to their gravy. I used to pay a quarter for the roast pork when I was younger, and it still isn't that much at eight dollars today.*[90]

One of Chinatown's legacy businesses: the New Lun Ting Café (called the "Pork Chop House" by faithful regulars). *Photo by author.*

The Pork Chop House menu is eclectic. It represents a blend of two cultures that epitomizes life in 1950s and '60s Chinatown with what once was loosely defined as "Chinese-American Food." Among its 2017 offerings are Thai fried rice with ground meat ($8.25), teriyaki roast pork with onions over rice ($8.95), ham and cheese with spaghetti ($8.25) and Shanghai noodle with pork, chicken or beef ($8.25). All include soup, a dumpling, a jiggly square of red Jell-O topped with a tiny dollop of whipped cream and coffee or tea.

The restaurant's top three requested items are the above-mentioned roast pork platter, oxtail stew and beef tongue with gravy. It is doubtful that any baby boomer ABC could rank these enduring favorites.

FOOD, FOOD, FOOD

"Pay No Attention to the Cholesterol!"

Ken Sproul first visited Chinatown as a child with his mother in the 1950s. He recalls how she would look over things in the food markets, pick some of them to take home and experiment in order to create what she thought could be reasonably called "Chinese food."

The Chinatown of my youth was Cantonese. As new immigrants have arrived from other parts of China and Asia, the food, the language and the non-tourist portions have evolved. In addition, parts of the Richmond and Sunset have become an extension of the city's Asian community and in some ways are more "authentic" than portions of Chinatown.

The Chinatown of my youth offered strange and often delicious foods and smells, fascinating produce, live fish and fowl, maybe even turtles and frogs, all destined for some dish or another. Food stores had dried things of unknown origin: fish, fungi, roots, spices, and even reptiles. Drug stores had boxes and bins full of medicines and remedies that didn't come with printed dosages. We experimented with dried fish and shrimp, but most of all, with dried mushrooms and fresh produce.

The meat and fish markets not only had cages of birds and tanks of fish from which you could directly purchase them dead or alive. They also had cuts of meat and parts of animals on display that were lessons in dissecting. I didn't know that pigs had so many parts; both exterior and interior.

The vegetables on sidewalk stands ran the gamut from the familiar to the totally unknown. Melons, eggplants, citrus fruits, beans, and greens came in a bewildering array of styles and shapes with very little in the way of descriptions or identification. Sometimes we would just buy and experiment.

The best part of the food markets were the places with prepared foods. Ducks and squabs hanging in the windows, salt chicken and the king of the hill: whole roasted pig. It was always a glistening golden brown that you could buy by the piece or by the pound. A magician with a cleaver would turn it into bite-sized pieces to fit into a carry-out carton. A whole duck would be reduced to fit into a quart sized container filled with juices. Pay no attention to cholesterol! Take it home and eat, but if you put it in the refrigerator it may look a little less appealing in the morning.

Outdoor produce shop on Stockton Street. Produce arrives fresh early every morning, and the best of it is quickly sold. *Photo by author.*

There were also steam tables with rice, noodles, squid, chicken, fish, shrimp and duck. With everything smelling great all were a great temptation. Bakeries with a range from steamed pork buns to almond cookies were the last stop.[91]

GREAT FOOD FROM GREAT OLD PLACES

The Best from the 1960s

Former Chinatown resident JuJu Lee provided a list of her favorite dishes from the 1960s along with the restaurant of choice in which she or her family once ordered each. All of the food and all of the restaurants were much simpler and more basic in nature than their modern-day versions. Not a single one of the old-time Chinatown dining spots played music or had a television set for diners to watch as they ate. Conversation-based social interaction was the order of the day. Most of the listed restaurants are

gone, although one of the best known, Sam Wo, recently reopened at a new location. JuJu calls her list "The Best from the 60s." [92]

- Tomato beef chow mein from the Chinese Kitchen.
- Beef casserole with raw egg from Jackson Café.
- *Op gun yee fu wonton* from Nam Yuen.
- *Sam see fun* (with abalone, chicken and *cha siu*) from Kum Hon.
- *Beef gon won ton* from Sai Yon.
- *Gai bow* from Yung Gee.
- Cold noodle roll with pork from Sam Wo.
- Custard pie from Sun Wah Kue.

Sun Wah Kue featured Chinese and American food and was located on Washington Street between Stockton and Grant, right by Ross Alley. Most Chinatown folks went there for the American fare that included three-course lunches or dinners centered on main dishes such as roast beef, pork chops or beef tongue. All were accompanied by Parker House–type rolls and pats of real butter on a tiny chilled platter. Breakfasts included bacon and eggs, omelets and waffles that came with individual portions of maple syrup in little spouted ceramic cylinders.

Sun Wah Kue's cash register was right by the restaurant's entrance. It was a large, manually operated beast of a machine that rang whenever opened; it sat behind a cage of gilded bars. There were family booths made of worn but polished wood panels to the left side of the restaurant. Every booth featured a patterned gray-hued marble top table large enough for about four adults and an equal number of kids. The main dining room was filled with circular tables for four that were also topped with gray marble. To the right of the dining room was the counter, topped in the same marble found throughout the restaurant, to which swivel stools were attached. The large stainless-steel coffee makers and glassed-in pastry shelves occupied the wall beyond the counter. Coffee was served in heavy beige-colored ceramic mugs for a dime a cup. The house special baked goods included the above-mentioned custard pie along with apple pie, orange chiffon pie (it was just called "orange pie") and sugar donuts.[93] As late as 1970, a pie to go cost ninety cents and the sugar donuts were a nickel each. Customers could elect to take two different types of half pies for the same ninety cents as for a whole one. There were also cakes, a memorable one of which was the Peanut Cake. It was a three-layered yellow type with white frosting generously sprinkled with crushed roasted peanuts.

Leland Wong, a longtime Sun Wah Kue patron, recalled stopping by just prior to its permanent closure: "One of the last times I walked in there it was pretty sad. Upstairs was leaking water into the restaurant and there were buckets to catch the water. The store was open as usual, but I don't think the restaurant part was serving food anymore."[94]

Jackson Café was on Jackson between Grant and Kearny. It had a long counter that extended along the left-hand side and bench-seated booths that went down the right-hand side. The cash register, a smaller, simpler and more modern device than the one at Sun Wah Kue, was behind a glass counter filled with candy and gum for sale. Except for its Chinatown ambience, the café easily resembled a typical American coffee shop of the 1950s and '60s. Like Sun Wah Kue, Jackson Café served both Chinese and American food. Unlike Sun Wah Kue, however, most of the diners at Jackson Café preferred to order Chinese or the hybridized Chinese American rice platters that were a throwback to the exclusionist bachelor days. The beef casserole listed previously as one of "the best from the 60s" was one of the café's popular rice plates. It cost about one dollar in the '60s and came with all the oolong (black) tea that one could drink. Other such plates that featured the main ingredient heaped upon a generous portion of white rice included beef stir-fried in oyster sauce (or with greens), oxtail, roast pork and beef tongue. All were nicely drenched in sauce or gravy. In the evenings, there always seemed to be several single men at the counter quietly having their rice plates for dinner. Two American dishes that a Jackson client remembered as his all-time favorites were veal cutlets and fried chicken.

Pretty much any of the other "best from the 60s" Chinese dishes could be found at Jackson Café. In the mid-1960s, a two-dollar order of tomato beef chow mein, always made with fresh tomatoes as well as onions and green peppers, would easily satisfy four fairly hungry people. A curry-flavored variant of this chow mein was also very popular at Jackson and other restaurants throughout Chinatown. Another chow mein favorite from Jackson was the *sang gai see chow mein* that, as indicated by its name, was made with fresh shredded chicken.

Gai bow were a chicken-filled version of the more famous *cha-siu bow*, or roast pork bun. Both came in either a steamed or baked version. Steamed gai bow bore a red dot of food coloring on their tops to distinguish them from the lookalike pork buns. The ingredients for the bread were essentially the same as for any yeast roll: yeast, flour, a bit of sugar and possibly some shortening. Another bow variant was the *lop cheung bow*, filled with the sausage of its name. The sausage is a hard and dried pork-based product.

The sausage's appearance is dark maroon-brown, variegated with grayish white globs of tasty fat, and it is shaped like a thin cigar. Appearance and questionable healthiness were never deterrents to the popularity of *lop cheung*. It has also been called *fung-cheung* (*fung* means "wind"). Back in the villages, the sausages would be hung in the open air to cure. *Lop cheung bow*, a little hard to come by in the present day, were easily distinguished from their roasted pork or chicken variants by their oblong shape.

Sam yee fun was three-flavored (or three-ingredient) stir-fried *fun*. *Fun* is a generally thick and wide rice noodle. One of its oldest and most popular versions is *gnau-yuk chow fun*—*fun* stir-fried with beef, soy sauce and onions. In the case of the listed "best from the 60s" version, the ingredients or flavors were stir-fried slices of abalone, chicken and *cha siu*.

One former Chinatown kid said: "I have always loved a good simple beef chow fun. I have tried to cook it at home but, even with the right ingredients which are pretty basic, it is hard to do right. I don't have a wok and I think that is the key. I have read where it is supposed to be cooked over really high heat, in a well-seasoned wok, and with just the right amount of oil. All I have is an electric stove and flat nonstick pans, so if I really want decent chow fun, it's off to a restaurant."

Noodle rolls, also called *cheung fun*, can be served either hot or cold. The word *cheung* refers to "guts" or "intestines," because the rolls look a bit like lengths of pig intestine. Popular in practically all dim sum places, it can be made with any variety of ingredients to include dried shrimp, ground beef, vegetables or roast pork. It can also be served plain. *Cheung fun* of practically any variety was a staple of Chinatown's old Sam Wo restaurant.

Sam Wo was a longtime Chinatown go-to place for families seeking comfort food, called *siu yeh*. The restaurant stayed open until 3:00 a.m. and always did a great takeout business. It was on Washington Street between Grant and Kearny and opened just after the San Francisco earthquake of 1906. It was only about ten or twelve feet wide and was three stories high. The kitchen was on the ground floor, and customers walked up stairs just to the right of the door to get to the dining areas. Since the restaurant was so narrow and crowded, food orders had to be sent up from the kitchen by a dumbwaiter. The dining rooms had marble-topped tables surrounded by stools. A former customer said:

> *Everything about Sam Wo was basic, but good and no-nonsense. They served chow mein, chow fun, wonton, jook* [rice porridge]...*all the things we loved to eat in Chinatown. It was always good, with quick service*

and very inexpensive. Back in the '50s and '60s, the waiter or waitress didn't waste time talking or setting the table. They asked what you wanted, came back with it and a pot of oolong tea, put it all in front of you with a pair of chopsticks and, if your dish called for it, a soup spoon and left you alone. I hated it when sometime in the late '60s or early '70s, the place got discovered by lo-fahn (non-Chinese). They would come in crowds and line up down the street just to get in. Then it got written up in tourist books and things got really bad. The out-of-towners didn't even know what to order. Before all that, I never had to wait to get in even if the place only could seat about thirty or forty people. I went one time in the '70s when I saw that there was no crowd and ordered my old standby: tomato beef chow mein. It was awful! They were using canned tomatoes.

Former Sam Wo customer Marilyn King bemoaned the loss of her one-time favorite stir-fried noodle dish, *gon lo mein*: "Sam Wo's gon lo mein had a distinct flavor. I think it came from being cooked with a combination of sesame oil and oyster sauce. I don't know where we can get anything even close to that any more. I met a cook once who cooked it and eventually became a part owner of Jackson Café. When he made beef gon lo-mein for me at his own restaurant in San Mateo I thought I was in heaven. Unfortunately, he passed on within a year. His son tried to duplicate the dish, but it was not the old school way and taste."[95]

JuJu Lee, a well-experienced aficionado of Chinatown lo mein, said: "It's hard to believe that not many can replicate the old school style of Cantonese cooking. Simple flavors. Good fresh ingredients. Good oil and not smothered in garlic or hot sauce."[96]

Sam Wo remained in operation until 2013. It was shut down for health and safety reasons that the owners found too expensive to address. Back in the heyday of the baby boomers' Chinatown, the deficiencies identified at Sam Wo, health and safety notwithstanding, were not uncommon in practically all of the neighborhood's eateries. Sam Wo was reestablished in a new location on Clay Street between Grant and Kearny in 2015. It has attempted to keep many of its old favorites on the menu.

In Chinatown, fresh seafood was never a problem, either in restaurants or at a market. Some markets on or near Grant Avenue featured outer walls that were actually the fronts of fish tanks. Live fish swam behind the thick glass; all a shopper needed was to identify a specific fish before it was scooped out with a net, popped on the head with a wooden bat and sold. Live crab or snails were often placed in pans or buckets on the sidewalk in

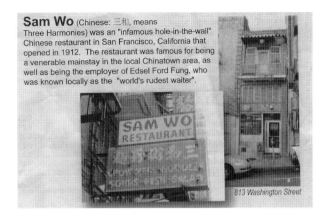

Sam Wo (Chinese: 三和, means Three Harmonies) was an "infamous hole-in-the-wall" Chinese restaurant in San Francisco, California that opened in 1912. The restaurant was famous for being a venerable mainstay in the local Chinatown area, as well as being the employer of Edsel Ford Fung, who was known locally as the "world's rudest waiter".

813 Washington Street

Pictures and history of Sam Wo from the back of its 2015 takeout menu. *Photo by author.*

front of a store. Fish that had already been killed, some of them cleaned or even fileted, could be found neatly stacked on crushed ice inside the store.

One former Chinatown kid recalled a family recipe made from fresh-caught fish. The resultant dish is a traditional one that is supposed to be eaten on the seventh day of the Lunar New Year celebration. The women of the family—mother, aunts and grandmother—would make a raw fish salad with pickled ginger, scallions, fried rice noodles, cilantro, sometimes preserved black eggs and lettuce. The dish would be topped off with lemon juice squeezed all over it.

Preserved black eggs have been called "100-year old eggs." The weathered and aged appearance that they take on is due to the preservation process. They look very much as if they had been around for as much as a century. In reality, the aging of the eggs can last as little as several weeks. The eggs are packed in clay mixed with other ingredients that allow for biochemical processes to occur that ultimately produce a black-colored product of strong and pungent flavors. These eggs can be from chickens, ducks or quail and can be eaten alone or used for flavoring.

CHINATOWN TAKEOUT

Like a Proto–Panda Express, but Better

A general characterization of the typical Chinatown family of the postwar period would likely include the descriptions "always busy" and "having little money to spare." Moms and dads often worked long hours for low earnings, and the kids could usually be found helping out in a family

business after school. If not working or attending Chinese school, older kids were frequently charged with caring for younger siblings and helping with household chores that sometimes included making dinner. The presence of shops and restaurants that made and offered good food to go at reasonable prices went a long way to offer some downtime for families around the dinner hour.

Several markets such as the Ping Yuen Supermarket (not associated with the nearby and similarly named housing projects) sat about midblock on Grant between Broadway and Pacific. It offered pre-cooked dishes from what could be called its "deli section," set behind a well-heated glass counter. Shoppers could order full-course dinners of complete dishes of vegetables, meat, seafood or fowl. Cooked white rice and desserts were also available. While Chinese families did not traditionally serve dessert, the American custom could not be ignored. One of Ping Yuen Supermarket's signature dessert dishes was a peach tart that had a pie-like crust upon which a canned peach half was placed. A swirl of whipped cream completed the delicacy, which came in an appropriately miniaturized foil pie pan. Ping Yuen may have also been the first place in Chinatown to offer baked *cha siu bow*. While the steamed versions found throughout Chinatown cost about a dime, the much larger Ping Yuen baked *bow* were sold for a quarter. Despite the greater cost, they tended to sell well as much for the novelty as for their larger size and generous and perfectly moist filling. Instead of just plain *cha siu*, the Ping Yuen bow included bits of onion, celery and other little things.

There were also small kitchens with a storefront that operated solely as takeout places. One such was the well-liked and versatile Chinese Kitchen. Several of its former customers remembered that it was on the corner of Mason and Pacific and that the Powell–Mason cable car line ran right past it. It was for takeout or delivery only, and some believe that it was opened by Johnny Kan (owner-operator of Johnny Kan's in Chinatown and Ming's in Palo Alto). One of its old customers thought that it was the first Chinese takeout place in the country and that they made your food to order. This former patron added that it was the prototype for the drive-up, takeout, fast-food chain currently seen everywhere: Panda Express. Chinese Kitchen's most consistently cited favorites were (in no order) tomato beef chow mein, won ton and gon-lo-mein.

There were also the clandestine takeout spots. Many restaurants had side doors that opened up to alleys. Most of these doors went directly to the kitchen, and they were usually at least partially opened to help keep down the heat from the stoves. People in search of prepared food would go to these

spots, catch the attention of a worker and place an order. In some cases, this would be a legitimate transaction, but in others, it was a means of extra income for the kitchen staff. "I really liked the 'covert' or 'contraband' Won Ton from Sun Hung Heung restaurant. The kitchen helpers sold it out the side door on Wentworth Place. They gave it to you in recycled cans, but if you brought your own pot, it was always a little cheaper."[97]

Another takeout regular recalled: "My mom used to bring her own pot with lid to Sun Tai Sam Yuen restaurant for soup. It sustained our family of four for a week!"[98]

Yet another bargain-seeking diner-in-a-hurry recalled that practically everybody in his family would go to Sam Wo for either *jook* or won ton and that they always brought their own containers. He spoke fondly about taking the train to Santa Cruz for the day once or twice each summer with his parents, aunts, uncles and cousins. Leaving from the station at Third and Townsend Streets, the train was called "The Suntan Express," and it stopped right at the beach and boardwalk. The family's picnic lunch was always jook bought ahead of time from Sam Wo. One of his mother's saddest moments was the time she forgot to take her jook container from the train after it returned them to San Francisco. She went on and on about how her container was the perfect pot for jook and how anything else she used after it was lost just wasn't the same. She went so far as to say that even the jook tasted different after that.

Kuo Wah: One of the Oldies

The Premier Restaurant in Chinatown

Very few of those born and raised in Chinatown have forgotten the old Kuo Wah restaurant. It had been established during the prewar era, so by the time the boomers came along, it was already a thriving place that was popular with the neighborhood's families. It was open from 10:30 a.m. until 3:30 a.m. An old menu from either the 1940s or '50s shows that a full dinner for one ranged in price from just $1.00 to $2.50. The items ranged from reasonably traditional Chinese dishes (*chow yuk*, bird's nest soup and wonton) to those concocted largely for the tourist trade (sweet and sour pork and egg foo young, for example). Won ton was helpfully described on the menu as "Chinese ravioli." The dollar meal would include soup, chow mein, fried

prawns and rice. The banquet table–sized dinner for seven cost $22.00 and included bird's nest soup, chicken wrapped in paper, chicken with cashew nuts, "Yangchow" fried rice, mushroom chicken chow mein, egg rolls, fried prawns and sweet and sour pork. Additional diners beyond seven would be charged an extra $0.25 per person.

Andy Young, the grandson of the original Kuo Wah owners, recently contributed his memories about the restaurant:

My grandfather Chin Mon Wah and his childhood friend Chin Kwok Yuen purchased the building in the late 30s. They remodeled it to house the Kuo Wah café at 942 Grant Avenue which served American style food. The part of the restaurant that was 946–950 Grant Avenue served Chinese food. The Lion's Den nightclub was in the basement and its entrance was at 942. This is where the bar was located at the time. The Lion's Den had shows featuring Chinese performers who would sing, dance, and tell jokes just like at the mainstream nightclubs of the era. The Gum Mon Hotel still remained in the building's upper two floors.

Sometime after World War II, I'm guessing the late/mid 50s the Lion's Den ceased to exist due to the changing times and became a dining room. Its bar was relocated to the main dining room which served American food. Many politicians, heads of state and dignitaries were hosted. We have the names of the signatories to the United Nations Charter written in Chinese characters from when my father hosted them when they met in San Francisco in 1945. The Kuo Wah, I'm told, was the premiere restaurant in Chinatown and was known world-wide.

In the early 60s my father undertook major construction. The Lion's Den basement, main floor Kuo Wah café, and second floor hotel rooms were remodeled into a single restaurant called the Kuo Wah restaurant instead of "café." The second floor hotel rooms were cleared to make way for a 300+ person dining room. An outdoor courtyard was created at the front entrance of the building so that diners could sit out on nice days to eat or have cocktails. Between '65 and '68 there was a nightclub in the basement called the Dragon-a-go-go which featured local bands. The group that I remember the most is The Whispers. They still tour. We also hosted lunch once a month for a "Theater in the Round" where Hollywood stars that were in town met the press. I have pictures of Bette Davis, Rip Torn, Elaine May, Mike Nichols, Buster Keaton and others. The general theme of the place was that of an old rustic Chinese village. We sold the restaurant in 1975 to investors. They rebuilt it once again to make a Hong Kong style dim sum eatery.[99]

Mister Jiu's: Something New

A Symbol of Hope and the Next Generation of This Neighborhood

Unless they have immediate family, usually an aging parent, still living in the neighborhood, many of those who grew up in Chinatown do not visit it much anymore. They cite the congestion and lack of parking as primary reasons why they stay away. Distance and the heavy Bay Area traffic deter those who have moved down the peninsula or to the East Bay. Those who remained in San Francisco also say that Chinese restaurants and groceries are just as plentiful in the Richmond and the Sunset. Several blocks of the Richmond's Clement Street have become what might be called a "satellite Chinatown." Even in neighborhoods where there is no significant number of Chinese or Chinese American residents, there are often shops, groceries and restaurants that can satisfy their needs.

Restaurateur Brandon Jew has been uncomfortable with the changes that he sees in San Francisco's Chinatown. He misses the presence of a closely knit and family-oriented neighborhood. He is particularly concerned that demographic and economic changes may bring about a downfall to Chinatown such as has already devastated similar communities across the country and even in Canada. Jew fears that once-thriving Chinese and Asian American communities in Los Angeles, Seattle, Vancouver, Chicago, New York, Boston, Philadelphia and elsewhere have become "ghost towns." In response to these concerns, he recently opened a new restaurant, Mister Jiu's, at the site of one of Chinatown's longtime stalwarts: the Four Seas. Brandon spoke about his enterprise: "To me this restaurant is hopefully going to be a symbol of hope and the next generation of this neighborhood. I think for a long time, a lot of other Chinatowns like L.A. or even Vancouver, they're becoming like ghost towns. The Chinese community doesn't really live there anymore. There's something I thought was special about this neighborhood. It's continued to be a place for immigrants to reside in. The restaurant is a place to celebrate the history and the vibrancy of this neighborhood."[100]

Brandon's family background is familiar to that of many boomer ABCs. His father was born in Toishan, and his mother's family was from Long Du, to the north of Toishan. His parents came to the United States in the 1920s to join one of Brandon's grandfathers who, he assumes, used fake papers for entry. Brandon recalls trips to the Chinatown markets

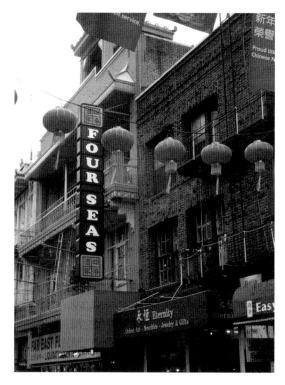

Left: The Four Seas Restaurant was a favorite Chinatown family banquet venue for half a century. *Photo by author*.

Below: Number 28 Waverly Street. Formerly the back of the old Four Seas, it is now the front of the new Mister Jiu's. *Photo by author*.

Two longtime favorite family restaurants. New places throughout the Bay Area have opened, so many old-time ABCs no longer visit Chinatown. *Photos by author.*

with his mother when he was a child. He maintains vivid images of the crowds of shoppers standing shoulder to shoulder as they pushed and pressed against one another in competition for what each deemed the "best" ingredients for that evening's dinner. He states that a large part of his inspiration as a chef comes from the way things were in his childhood—the way Chinatown was in its postwar glory days. He strives to carry out and express the traditions of his parents through what he hopes to do at his restaurant.

> *We're looking at doing red egg parties. To have a space that we can host parents to have a red egg party for their kid, those are the kinds of celebrations I want to continue for our culture. If we are able to do a wedding here, that would be cool, too. In general, I think we're looking to just have a place that people can celebrate in. And we hope that people will come here to celebrate the food and the neighborhood, and the history of this neighborhood, and the future of this neighborhood, too.*[101]

AMERICANIZATION THROUGH DESSERT

Blum's Koffee Krunch Kake Is to Die For

For Chinatown baby boomers, dessert was not a part of most meals. Dessert was simply not a "Chinese thing," the squares of red Jell-O from places like Sun Wah Kue or New Lun Ting notwithstanding. To be sure, there were numerous bakeries that produced goods such as pies and cakes, but these were often what afternoon callers would bring to the homes of their hosts. The bakery items would then be served with coffee during general conversation. A major exception was when there was a birthday celebration. In such cases, a cake from places like Eastern Bakery, Sun Wah Kue, Ping Yuen (supermarket) or elsewhere in Chinatown would be served, complete with candles and ice cream.

One bakery outside of Chinatown that was known to many of its residents, both young and old, was Blum's. There were several of them, but the nearest and most convenient was at Union Square. It was a small shop in which clients could sit with coffee over baked goods. Most just popped in to get something to go. The last of the Blum's closed in the 1970s. Its trademark cake, the one most revered by those living in Chinatown, was its Koffee Krunch Kake. It was a simple concoction. An airy sponge cake was baked with the flavors of vanilla and lemon. Heavy whipped cream was then applied between its layers as well as on top and all around the sides. It was then covered with crushed pieces of Blum's signature coffee crunch candy.

Cooper Chow recently wrote:

> *You can still get the old Blum's Koffee Krunch Kake at Japantown. Walk into the Super Mira Market at the corner of Sutter and Buchanan Streets and turn right. Single slices sell out by noon or earlier, but a whole cake to go is available all day. They are made daily by Tom Yasukochi, an 80 year old pastry chef. I have heard that Mr. Yasukochi learned how to make the cake 40 years ago from a former partner who was a former Blum's candymaker.*
>
> *My mom used to get a whole Koffee Krunch Kake from Blum's for super special occasions like when relatives came to town from Phoenix. Otherwise she would regularly get strawberry shortcake, apple pie, or custard pie from the old Ping Yuen Supermarket near the corner of Grant and Pacific. Eastern Bakery still makes a Coffee Crunch Cake, but I can't compare because I've never had it. It was always Blum's Koffee Krunch Kake for us back in the days. It was to die for.[102]*

Left: Eastern Bakery's coffee crunch cake. Some Chinatown kids claimed it was better than the original Koffee Krunch Kake from Blum's. *Photo by author*.

Below: The old Eastern Bakery sign. Faded, chipped and rusty, it was recently replaced by a new look-alike. *Photo by author*.

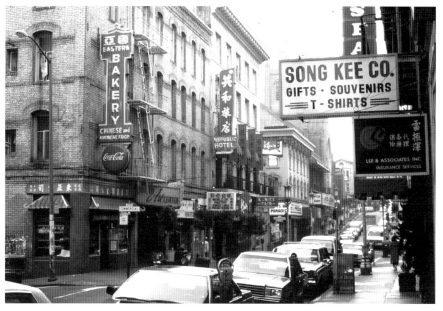

Annie Leong Lum stated: "I have good memories of those cakes. I used to buy the coffee crunch from Blum's until they closed. I tried Eastern Bakery's version but it wasn't as good. Chinatown's coffee crunch cake has always been too light, airy, and not sweet enough. I also tried Japantown's once many years ago and if I remember correctly it was very good. Yum! I think I need to make a trip there to satisfy my craving."[103]

EGG ROLLS, EGG FOO YOUNG AND MORE

We Asked If It Was Really Chinese

In talking about his new restaurant, Chef Brandon Jew commented that there were some classic old Chinatown dishes that he hoped to perhaps reinvent. He stated that, in the case of many dishes, there was never a true recipe to begin with. One dish he mentioned was egg foo young. "Most of those who grew up in Chinatown were well aware of things like egg foo young, sweet and sour pork, egg rolls, chop suey, and the host of other things that they never ate at home. Those were, for the most part, tourist foods, or not real Chinese food. That did not keep some from trying them and even enjoying them."[104]

P.J. Leong, a former educator from San Francisco's Chinatown, was very clear about her favorite but probably never-served-in-China Chinese food. "Sweet and Sour Pork! That fried pork with sauce! It was such a treat to go to a red egg and ginger party buffet because they served 'gwai lo' [white man] foods there. We didn't get sweet and sour at home. I still like it, but now I get the sweet and sour chicken! And a friend told me that her favorite is also sweet and sour pork made perfectly. She complained that most that are cooked nowadays are always soggy and coated with sauce. If anyone knows a place that has good sweet and sour; let us know!"[105]

A cousin of Darryl Eng's recalled a home-cooked meal that his father once made:

> *My dad was born in China. He was a fun-loving person who enjoyed doing fun and nice little things for us kids. One day he said that he was going to make us something special for dinner: egg-foo-young. We asked if it was really Chinese, and he said something like, "Of course it is! I'm making it and I'm Chinese and you're going to eat it and you're Chinese, right?"*
>
> *We watched him beat up a bunch of eggs, slice bean sprouts, green onions and cha-siu. He then pan fried it all until he had a stack of them on a plate. He then put them in the oven and told us to go play. He would call us when they were ready. A short while later we were at the table, each of the three of us and my parents with an egg-foo-young on our plates. I think we had forks instead of chopsticks. They looked fine, but I wasn't totally comfortable for some reason as I took my first bites. It took me a few moments, but I figured it out. "Can I have some catsup?" My dad brought it to me and laughed, "Ah; you're just too American!"[106]*

FRANCES AND CHERYL

DISCOVERING CHINATOWN THROUGH MARRIAGE

*T*wo non-Asian women who met and would become sisters-in-law offer their views about San Francisco's Chinese American community. The two women, one of whom subsequently divorced her spouse, married brothers who were born in Chinatown. They describe their experiences with their Chinese American family as well as with their discoveries in Chinatown. Since the couples moved away from California after marriage, the two wives were only rarely together at the same time at the home of their Chinese in-laws.

FRANCES MATHEWSON-LEONG, CHINESE BY MARRIAGE

"It Was Sometimes Uncomfortable to Be with the Leongs. And to Think, I One Day Became One"

Frances Mathewson lived in an apartment with a roommate in San Bruno after moving to the Bay Area from Riverside in the early 1970s to enroll as a graduate student at San Francisco State College.[107] She first met her husband-to-be, Glenn Leong, in one of her classes. The two of them happened to sit next to each other. Frances had not known anyone who was Chinese before she started her coursework at State. Her only previous experiences

with a Chinese American or ABC had, coincidentally, been with another classmate whom she had earlier sat beside in another class, Dennis Woo. Frances and Dennis became friends and went on several dates. Although they had enjoyed each other's company, a relationship did not develop, and they eventually went their separate ways.

Frances remembers that she had been attracted to Dennis because he was a nice guy rather than because he was Asian. Her experiences with Dennis left her comfortable to explore a friendship with her new Asian classmate Glenn. While both of her Chinese American friends struck her as thoroughly Americanized, she could not help but wonder if they might show significant cultural or behavioral traits that were specifically Asian. She simply did not know what to expect. Neither Dennis nor Glenn seemed to be much different from any of the Caucasian boys she had dated or had as boyfriends earlier.

Gradually, Frances found herself attracted to Glenn and enjoyed his company enough to begin thinking of him as a boyfriend. That progress in the relationship soon led to the inevitable meeting of his parents. Glenn had briefed Frances with the information that his mother was an ABC who was a bit old-fashioned and that his father, born in China, had come to San Francisco through the Angel Island Immigration Station when he was eighteen. He reassured Frances that they both spoke English, although his father did so with a fairly heavy accent. Glenn also told Frances he had a brother and a sister living at home. Glenn was almost ten years older than his brother. The two younger Leongs were a year apart in age and still in high school.

Glenn took Frances first to meet his father at his workplace: the National Dollar Store on Fillmore Street. Mr. Leong was the store manager. It was close to noon, so the three of them went to lunch. They all walked across the street to a small restaurant in Japan Town.

Glenn's father was nice. He shook my hand and smiled as he did so. I do not remember what we talked about…it probably wasn't anything important, but I was relieved that Mr. Leong appeared cheerful and sincere about everything we had to say. He had a pretty heavy accent, and sometimes I couldn't understand what he was saying. In the end, it didn't matter. I was just happy that he seemed to be sincerely interested in me. I also had never had Japanese food before, but with both Glenn and his father explaining it to me and helping me to order, everything turned out fine. Until he got transferred to the Dollar Store in Richmond, Glenn and I would often stop by the Fillmore store to

meet his father for lunch at Japan Town. Those were always pleasant times for me, and I would learn so much about the Chinese in America during my increasingly detailed conversations with Mr. Leong.

An Angel Island Immigration Station Admissions Interview

"His Face Was Flushed, So He Must Have Been Lying"

Frances learned a lot about Glenn's father through the chats that she shared with him during their Japan Town lunches. Even Glenn admitted that he had not heard some of his father's stories before. Frances was fascinated by what Mr. Leong had to tell her about his earliest days in the United States.

I always knew about immigrants coming to America through Ellis Island in New York Harbor, but until I met the Leongs I had never heard of things like paper sons or Angel Island. Glenn told me that his dad had entered through Angel Island, but he never explained or offered any details. I don't think he really knew that much about it. I didn't know that Chinese were not allowed into the United States except under very strict provisions until 1943, and I was really surprised at how harsh the conditions were for Asian immigrants, who had to be cleared through on that island in San Francisco Bay.

I was amazed at how a lot of Chinese managed to get in by using false papers. That's how I found out what "paper son" means. It's basically where someone already in the U.S. legally takes money from someone in China to claim him as a "son" for immigration purposes. The immigration officials tried to catch people sneaking in by interviewing everybody about their supposed family backgrounds. I was glad that Mr. Leong was not a paper son, but I felt really bad for what he had to go through.

During his interview, Glenn's father told me that he was asked about the arrangement of houses in his home village, the location of the village well and the distance to the nearest market. He told me that when asked about the color of the main door on a particular house, he answered, "red," but was immediately told that he was wrong and that it was actually green. As far as he knew, that was the only question that he missed. After the interview, which lasted over an hour, Glenn's father was told that his face

Left: The Angel Island Immigration Center did not welcome the Chinese so much as attempt to bar them from entry. *Photo by author.*

Below: Bunks in the male detention barracks at the Angel Island Immigration Center. *Photo by author.*

was flushed so he must have been lying. He was only seventeen years old at the time, and he said that he was really nervous but was telling the truth. The immigration personnel did not believe him, and he was not initially granted entry. Eventually, the well-to-do San Francisco family that Glenn's grandfather worked for as a cook and houseboy vouched for Mr. Leong, and he was allowed in to San Francisco and the United States. This was in about 1934.

A former Angel Island immigration inspector recalled the general nature of an interview:

> *We started by getting the data on the applicant himself: his name, age, any other names, and physical description. Then we would ask him to describe his family: his father—his boyhood name, marriage name, and any other names he might have had, his age, and so forth. Then we would go down the line: how many brothers and sisters described in detail— names, age, sex, and so forth. Then we would have to get into the older generations: parental grandparents; then how many uncles and aunts and they had to be described. Then the village: the district, how many houses it was composed of, how arranged, how many houses in each row, which way the village faced, what was the head and tail of the village. Then the next door neighbors. Then describe the house: how many rooms and describe them. What markets they went to…we had to get the main details of* [the home] *and how the family slept, what bedroom each occupied. Sometimes it would take three or four hours to examine each one.*
>
> *Major discrepancies would be cause for deportation. For example, if an applicant said his village consisted of ten houses and five rows, two houses in each row and the alleged father said 30 houses and ten rows…or if the applicant said his father had three brothers and the father only had one brother. It was a question of testing them on family history. I don't see how we could have handled it in any other way in the absence of* [more or better] *documentary evidence. When a person came in from a little village, who would know them? There was just one way of finding out if the family belonged together as it was claimed and that was by testing their knowledge of their relationship.*[108]

Frances met Glenn's mother one weekend at the Leongs' house, which was on Tenth Avenue in the Richmond. She mainly remembers that she was pretty nervous about it. Things went reasonably well, and Frances admits that her own nervousness made her feel more uncomfortable than she probably needed to.

Glenn and Frances eventually moved in together. They rented an apartment near Ocean Beach in the Sunset. Frances does not think that either of Glenn's parents had any difficulty with it.

> *It seemed odd to me that Glenn's mother never addressed me by my name for about two years. Glenn said something about how Chinese families were*

Hand-carved poems decrying the harsh conditions endured by hopeful immigrants being held on Angel Island. *Photo by author.*

rarely openly affectionate and that family members usually addressed one another by title or by whatever each person's standing in the family was rather than by name. He even told me that his father called him "Boy" a lot while he was growing up and that he sometimes slipped and still did that. His mother was American born and had to be American enough to be comfortable calling me by name. On the other hand, I only ever addressed Glenn's parents as Mr. or Mrs. Leong.

Although I spent more time with his father than with his mother during the early part of my relationship with Glenn, Mr. Leong was still pretty reserved in a lot of ways. Between my own observations and what Glenn would tell me, I understood that conservative behavior was just a Chinese cultural thing. It wasn't customary for them… the Leongs or any other Chinese…to be expressive, or personal or emotional. This was the opposite of my own family, so it was sometimes uncomfortable to be with the Leongs. And to think, I one day became one! The Leongs always asked about my parents, though, and I always felt good about that.

VISITING CHINATOWN

"I Loved It"

As Frances and Glenn grew closer together, she took increasing pleasure in seeing and experiencing Chinese culture as it was to be found in San Francisco and as Glenn and his family practiced it. Frances had determined early on that Glenn was, at best, only nominally interested in being Chinese. She simply saw him as another American, and that was how she knew that he preferred it. She was happy, however, that he would take her to Chinatown and show her the "native" side of it.

Whenever we went to Chinatown or the Chinese part of Clement Street, I loved it. It was a new world that was being opened up to me. I reveled in the fact that I was not just another tourist spending a part of a vacation afternoon going through Chinatown's streets and shops. I really enjoyed the little stores, places to eat and movie theaters. And the food stalls on Stockton Street made me feel as if I were in a market somewhere in China. There were a lot of familiar things, of course, but there were so many things that I had never seen or even imagined before. As time went by, it was fun to look at some of the Stockton Street produce, meats, prepared foods and snacks and know that I had eaten some of them and liked them! Often I would be the only non-Chinese person in some of the places we went to. I didn't feel odd or out of place. I just enjoyed it so much. I remember going to the movies, and people, especially the young kids, would just look at me. I felt like a Chinatown insider. This was especially true when Glenn would point out places he went to or where he played when he was younger, or where his friends used to live. I just thought it was all very cool.

One of the first times I ever had dim sum was in the Hang Ah Tea House. It was in a narrow alley and it was a dive, but in the good sense, like when a place is really something unique and you get a special feeling just being there. Glenn ordered, of course, and I don't think there was anything that I didn't like. One time, shortly after that, I tried my hand at making some dim sum, since I had really begun to enjoy eating it. I even made my own cha-siu from scratch for the steamed cha-siu bow [pork buns]. *I made bok-tong-go* [sugary rice gelatin], *because Glenn told me he had always liked it, siu-mai* [meat dumplings] *and a few other things. I wasn't trying to prove that I could be Chinese or something. I have always enjoyed cooking, and I thought it would be fun and challenging to try to make something that was so exotic to me. Glenn told me that he thought it all turned out pretty well, and he expressed admiration for what I had done. I was pretty pleased, of course. Dim sum is very involved and even complicated to make. It was also totally foreign to anything I had ever tried before in a kitchen.*

Well, when I took some to the Leongs, I was disappointed that Mrs. Leong seemed a little critical. I'll admit that she was trying to be kind, but I was bothered nonetheless. Glenn explained that all Chinese take their dim sum very seriously and they do not tolerate even the slightest imperfection. He said that his mother just "slipped" into her "Chinese mode" out of habit. I think he was just trying to cover for her.

Left: Dim sum. Payment used to be calculated by the number of steamer baskets. Some clients would hide or toss them out windows. *Photo by author.*

Below: Hang Ah restaurant is the oldest continually operating dim sum establishment in San Francisco. Established in 1920. *Photo by author.*

Then there were the Chinese movies. I was initially worried that I wouldn't like or understand them, but it wasn't long before I became a big Shaw Brothers fan. It really helped that there were subtitles in English as well as in Chinese. We usually went to sword-fighting and martial-arts films. The costumes and settings were historical, and I guess that I would roughly compare that kind of film to the American Western. My favorite actor of the 1970s was David Chiang. And my all-time favorite movies are Heroes Two *and* Five Shaolin Masters. *I became a big Bruce Lee fan, also; but David Chiang and the two Shaw Brothers films I mentioned are the tops for me. I liked Alexander Fu Sheng, too. It took a while for me to find them, but once I did, I made it a point to buy the Shaw DVDs, and I still have them. I went to the Great Star Theater on Jackson Street most, but I also remember the Sun Sing Theater. Glenn never took me to a musical or any of what he called the "girly movies." I guess I don't miss what I don't know. I couldn't get into those salty preserved plum snacks or the melon seeds that Chinese people munch on at the movies, though. But going for siu yeh* [snacks or good-old Chinese comfort food] *afterward was the best!*

I enjoyed the orange pie at Uncle's on the corner of Waverly and remember that a slice of pie and coffee came to a quarter in the early '70s…a dime for the coffee and fifteen cents for the pie. Glenn always liked Sun Wah Kue for its apple pie, but for some reason, I never cared for the place. I also remember eating tomato beef chow mein, or its variant with curry at the Jackson Café. Chow fun was another favorite of mine. A couple of times, we would just pop into one of the places that had ducks and siu-yuk and cha-siu hanging in the window to buy a half pound of something to snack on while walking down Grant or Stockton. A couple of times, Glenn would coach me on how to say things, and I would go in by myself to get our snack. I thought it rude one time when a counter woman laughed at what I said. I knew that she understood me. I wouldn't have laughed at her English.

OLD CHINESE LADIES IN LARGE GROUPS

Raw Terror

After about four years of dating and living together, Frances and Glenn got married. Settling into married life and forging closer ties to her in-laws,

Frances remembers how Glenn's mother would spare her no detail about her battles with the older immigrant women who had come to San Francisco in the late 1960s or early 1970s.

> *Since Glenn's mother had never learned to drive, she depended on the San Francisco Municipal Bus System. She would often take the bus from work to Chinatown in order to do her food shopping on Stockton Street. Whenever she was at the produce stalls, she always said that she felt besieged by her fellow shoppers. She called them "pushy" because, according to her, whenever she was at one of those sidewalk produce shops, "loudly gabbing, shabbily dressed and rude old hags" would push her aside and snatch whatever fruit or vegetable she was looking at "practically right out of my hands." She repeatedly stated that they acted like "a bunch of ignorant peasants who thought they were back in their old villages."*
>
> *After her shopping or other Chinatown errands, Mrs. Leong would have to get back on the bus to get home. She seemed to enjoy complaining about it so much that I thought it was a little funny. She would say things like, "Those damn peasants are so uncivilized! They don't wait their turn to get on the bus. They just push and shove. They don't care if they step on you or knock you down!"*
>
> *Even though she spoke Chinese a lot and acted Chinese in certain ways, Mrs. Leong was thoroughly American. She sometimes complained about how frustrating it was for her to understand some of her coworkers in her office building who were recent immigrants from Hong Kong. They would only speak Cantonese to one another, which Mrs. Leong couldn't understand. She would go on to me about how they were so unwilling to act more American. I thought it was pretty funny.*

Since neither Glenn nor Frances had a car, they also relied on the bus. Looking back, Frances remembers it all too well. Thoughts of the number 30 Stockton bus, ever so slow and ever so crowded as it lurched its way through Chinatown, still evoke the raw terror that only hordes of hissing, cackling and scrabbling Chinese harpies could produce as they elbowed, stomped and shoved their way past any and all unfortunate or foolish enough to stand before them. It seemed to a bewildered and overwhelmed Frances that these women—dumpy and diminutive, dusty and disheveled—were in a constant struggle for survival. To her, they all bore the hardscrabble look of people who had always been forced to fight for every little thing they could get just to get by.

More Paper and Angel Island Again

Mrs. Leong's Father Paid a Matchmaker in China

Unlike her husband, Glenn's mother did not have much to say about her childhood or adolescence. Whenever Frances asked her about it, she would get noncommittal responses such as, "Oh, you know. I just went to school, played with my friends and then got a job and got married. There's nothing special to tell." Frances's curiosity had been piqued by her father-in-law's stories, and she could not help but wonder if there might not be something as interesting about Mrs. Leong and her side of the family. Since she was always comfortable talking with Glenn's aunts, uncles and cousins, she managed to slowly learn quite a bit about her mother-in-law and her family.

> *Mrs. Leong's father was a paper son who first entered the United States in 1903 while he was still a teenager. One of Glenn's cousins who is very into the family history sent me a copy of an immigration department document about their maternal grandfather. Part of it reads as follows:*
>
> *"Wong Hung Fong* [is] *the minor son of Wong Si Fong and that said Wong Si Fong* [is] *a merchant lawfully domiciled and resident in the City and County of San Francisco, State of California, and engaged in business therein as a member of the firm of Nom Sang Lung, & Co., which said firm is engaged in buying and selling and dealing in merchandise at a fixed place of business, towit—at No, 900 Stockton Street, in the said City and County of San Francisco."*

The man who would become the father of Glenn's mother as well as several aunts and uncles was a paper son who listed his paper father's home village of Nam Lok as his own. His actual village was Fong Han. Rather than Wong, his real surname was, in fact, Lew. Unlike his father, Glenn's mother did not elaborate on how her father's Angel Island interrogation went. It is apparent, of course, that he learned about Nam Lok village well enough to quickly gain entry.

His mother did, however, tell Glenn stories about her childhood to entertain him when he was very young. He passed some of them on to Frances as best he could. She recalled one of them:

> *Mrs. Leong's father had eight children who survived by his first wife. Mrs. Leong was the second-youngest one. When she was just three, her mother*

had become severely ill with tuberculosis and asked to be allowed to return to China so she could be buried on native soil. Her eldest brother, who was fourteen at the time, and one of her sisters, who was eight, accompanied their mother on the trip. Glenn's grandmother died just one day out of Hong Kong, however, and his future aunt and uncle stayed in China for a year before returning to San Francisco in 1930.

When Glenn's uncle and aunt arrived back in San Francisco, his grandfather decided that he had too many children and too little money with which to care for them. The two youngest ones, Glenn's mother to be and her younger sister, were sent to an orphanage.

Glenn's mother and aunt were sent to what is today called the Gum Moon Women's Residence and Asian Women's Resource Center at 940 Washington Street in Chinatown. When Glenn's mother and aunt went there in 1930, Gum Moon (meaning "Golden Door" in Toishan Chinese and founded in 1868) was still known by an earlier name, "The Oriental Home." It was a full-time orphanage that kept girls until the age of eighteen. The girls would attend school outside of Gum Moon but earn their room and board by working around the residence. The older girls also helped with the younger ones. Over the years, Gum Moon's mission has evolved with changing times and community needs, but its general philosophy of providing aid, education and spiritual guidance to women and children with neither a family nor means of self-support has remained constant.

Frances continued:

Mrs. Leong, even though she was older than the sister she was with, could not adjust to being at Gum Moon. She cried all the time, and the staff members were at wit's end. Eventually, the family's oldest daughter, only in her early teens, made a commitment to her father, Glenn's grandfather, to personally take care of her distraught little sister. This aunt was already tending to her other five siblings, so she thought that one more wouldn't make that much of a difference. Since her other sister seemed all right with living at Gum Moon, she was left there. Glenn's senior aunt, however, did make it a point to pick her youngest sister up every Friday evening so that she could be with the rest of her family on weekends.

Meanwhile, Glenn's grandfather paid a matchmaker in China to find a replacement wife who would come to San Francisco to help care for his children. He stipulated that the woman should be older and neither any longer capable of bearing children or having any young children of her

own. The match was made sight unseen, and the woman traveled to San Francisco as a paper daughter. She was to marry Glenn's grandfather once she cleared through the immigration process at Angel Island.

There were two problems, however. The first was that Glenn's grandfather's prospective new wife turned out to be a far younger woman than was expected. The second problem was that she somehow could not keep the information that she had studied for the immigration interrogation straight. She was detained on Angel Island for about a year. As Glenn's grandfather still had nobody to help with his children, Glenn's youngest aunt stayed at Gum Moon.

Glenn's grandfather quickly married his paid-for bride once she got free of Angel Island. She soon became pregnant, and the arrival of her first American-born child was followed by four more. Some ten years after her stepmother's arrival in San Francisco, Glenn's grandfather asked the aunt who was still living at Gum Moon and twelve years old by then if she wanted to return home. Her eldest siblings were married, and several others, Glenn's mother among them, were old enough to care for themselves. There were, of course, three young stepsisters and two even younger stepbrothers to consider. Glenn's aunt figured that she would wind up having to care for them and decided that Gum Moon was a far better option. She stayed at her "home" away from home until she graduated from high school and found a job as a secretary for a company located in downtown San Francisco.

FULL INCLUSION AS A FAMILY MEMBER

"I Really Enjoyed Those Times"

One of the more interesting things that happened to me as a Leong was when I had a bad case of gastrointestinal discomfort while visiting the family. I was very uncomfortable, and there was no way I could hide it. Everyone was concerned, and when I explained that I had been feeling badly for several days, Mr. Leong told me to get my coat on, because he was going to take me to get something for my problem. We rode the bus all the way into Chinatown from the Richmond District, and we wound up in a dingy and pungent-smelling little storefront place that was an herbalist shop. After the bus ride and the walk from the bus stop to the shop, I was feeling a little worse than even before, so I don't remember much of what

happened. Mr. Leong said a whole lot of things in Chinese while pointing at me. The old Chinese guy behind a counter filled with odd-looking things looked at me and nodded a lot. He then hustled around pretty quickly to pull stuff out of this drawer or that one or out of one cabinet or another and finally had a pile of what looked like dust, dirt, twigs and bark on a square of paper. He spoke more Chinese with Mr. Leong, wrapped everything up into a little bundle and out we went. Back at the house, Mr. Leong had me sit to rest while he boiled up the mix from the herbalist. It neither smelled good or bad, but it certainly had a distinctive odor. Glenn finally came in with a teacup and told me to drink it all down. I looked at it with some doubt, and Glenn stepped a few steps back and repeated that I had to hurry up and chug it. I did. It wasn't long before I was feeling better. Except for not feeling well, it was really a fun and exotic adventure for me.

The Leongs went out for dinner a lot, and Glenn and I often went with them on weekends. I really enjoyed those times, because Glenn's father, who was the family head and in charge of ordering, always selected authentic dishes. Most Chinese dishes were authentic to me because I had never had any of them before. Mr. Leong never picked anything off the menu just for me, and that made me feel like I was fully included into the family. It even made me feel a bit Chinese. Conversation became easier, too. The Leongs spoke in a blend of only Chinese, Chinese and English within a single sentence and English only. They spoke English to me, of course, but the way they were so quickly and naturally able to switch words and phrases back and forth made me feel that I was always fully engaged in whatever discussion we were having.

The greatest moments of acceptance for me were my graduation from medical school and the red egg and ginger party that the Leongs gave for our daughter Amy. Glenn explained that the red egg and ginger party was something that every Chinese family would have done and that it was not just for Amy or for me per se. I understood that, but the underlying sensation that I had through it all was that I was being acknowledged and acceptance was being conferred on me for providing the family with a daughter. The party was filled with lots of talking, laughing, smiling and even some hugging, so the celebration was really very special to me.

I did not go to medical school in California, so when Mr. and Mrs. Leong and Glenn's aunt who had lived at Gum Moon and her husband drove all the way from San Francisco to my graduation, I was extremely flattered. By that time, Mr. Leong, who suffered from weak lungs and heart problems, was not walking much and had to use oxygen. He was not in too much

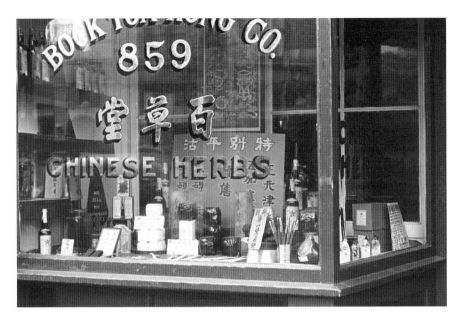

Doctor's office, clinic and pharmacy, all in one spot. *Ken Cathcart Collection. Courtesy of Schein and Schein.*

distress, but it really moved me that he as well as the others would make the effort to see me graduate. For me, it was a final acknowledgement and a proof of my worthiness to them as a full daughter. After the graduation ceremony, we went to one of the local Chinese restaurants for a celebratory meal. The menu had Chinese as well as English on it, and Mr. Leong, in his usual role, did the ordering. It was an enjoyable meal. Walking out, Mrs. Leong said that she thought the food was good but not quite as good as it would have been back in San Francisco's Chinatown. I thought back to the episode with my dim sum and smiled.

CHERYL'S SPOUSE, IN-LAWS AND NEW FRIENDS

"To Me, They Were Just Like Anyone Else"

Cheryl is in her early sixties.[109] She grew up in East Oakland in a mixed neighborhood of whites, blacks and Latinos. There were no Asian families nearby, however. Although they were well aware of Oakland's Chinatown,

Cheryl and her family never saw a need to go there. It would not be until she was in her mid-twenties that she would meet her former husband. He was born in 1956 at Chinese Hospital, and Cheryl was born at Stanford a year later. Cheryl remembered:

I was working in San Francisco as a legal secretary, but I lived in Oakland. I liked shopping in San Francisco's downtown partly because it was so close to where I worked. I met my ex-husband in Macy's on Geary Street. He was a sales assistant in the bedding department, and I was looking for some bedding. Neither of us was dating anyone at that time, and we hit it off and began to go out. He was full Chinese, but that had nothing to do with why I was attracted to him or liked him or eventually married him. I didn't see him as unique or extraordinary because he was Chinese. In fact, he eventually introduced me to several of his coworkers who were also Chinese Americans. After more than thirty years, I am still friends with one of them because we were both legal secretaries and runners and we would often meet to go running and train for races. We talked about everything and anything, but it was the usual girlfriend-type things. Our different ethnic backgrounds were of no consequence at all.

Clearly, after I met and became involved with my ex-husband's family, I saw or was introduced to things that were Chinese. They often had authentic family-style Chinese food, which I had really never had before. There were frequent Sunday night dinners at their home that were prepared from ingredients that my mother-in-law and father-in-law acquired in Chinatown. There is very little of it that I didn't like. Well, there were a few things like chicken feet that I just couldn't get into. My brother-in-law would taunt me at restaurants with them. He also delighted in teasing me with sea cucumbers, which I once made the mistake of asking him about. Oh, a whole steamed fish with head and eyes all in place was sort of gross to me, too. I was quite taken by my father-in-law insisting on eating just the head and tail because he wanted the rest of the family to enjoy the best parts of the fish. My husband's parents spoke Chinese to each other a lot at family dinners, and I had no idea what was being said. Very often, I would ask my husband, but his Chinese had gotten so bad that he could only pick up an occasional word or two. It left me pretty frustrated. The house had a lot of Chinese furnishings and artwork in it, but I never looked at any of it as "foreign" or "Chinese." To me, they were just like anyone else that I knew and liked.

CHINESE ART AND HISTORY

"I Was Really Fascinated by Everything He Told and Showed Me"

From very early on, Cheryl found her father-in-law to be a very interesting person. He had only gone through the equivalent of two years of high school before arriving in San Francisco from China at the age of seventeen prior to the start of World War II. He spoke English with a Chinese accent, but that never bothered Cheryl. She remembered:

> *I became interested in Chinese history and culture because of my father-in-law. He was a very kind person, and I always felt comfortable with him. He liked to show me the artwork that he had in the house. He especially loved to talk about jade. He would show me how a good piece of jade was translucent, and if you looked closely, it would have tiny crystals throughout it. He would explain how his jade art pieces were made and what they were originally used for or what they symbolized. He did the same thing with*

Sidewalk shoppers on Stockton Street, with one of the four Ping Yuen housing projects in the background. *Photo by author.*

149

Jade belt fastener in the likeness
of a mother dragon with her baby.
Photo by author.

the many ivory pieces that he had as well. *My brother-in-law once asked
me if his dad was boring me. I told him, "No." I was really fascinated by
everything he told and showed me.*

*My father-in-law loved to show me pictures from his many art books. He
would talk for hours about a painting, for example. I learned so much about
artists, styles of painting or calligraphy and the different Chinese dynasties
and historical periods. I think the one thing that captured my attention and
imagination about all these things was the sincere and loving way in which
they were told to me. Over the years, I think that I have forgotten a lot
about these things, but I will never forget the openness and fondness that my
father-in-law showed to me through his talks about Chinese art and history.*

*I went to Chinatown and Clement Street regularly with my in-laws for
shopping trips. It surprised me at first how they would be very careful about
what store they went to for certain things. There was always the "best
place for produce" or the "only decent shop for chicken" or such-and-such
a bakery for certain types of dim sum. It seemed like a lot of trouble to me,
but I gradually got used to it. It seemed more fun or more of an adventure
than going to Safeway for one-stop shopping. I learned to appreciate that
different places did have different quality things; even if they were the same
sort of things. Now I shop that way as well. I have my favorite spots for
each of the things I need. I will only go to a supermarket for paper goods
or cleaning supplies.*

SOME VERY SPECIAL MEMORIES

"You Have Always Been Like a Daughter to Me"

I got along well with both of my in-laws, but after my father-in-law passed away in 1981, things really changed between my mother-in-law and me. She became much more open than ever before. She was even very willing to share personal or intimate things with me. I thought that she had become lonely without her husband and with all of her children grown and out on their own. Our relationship was a very positive one, and instead of being my mother-in-law, she started acting like a friend. I felt badly for her, of course, that she had lost her husband, and it felt really good to grow closer to her. I missed my father-in-law terribly as well, so I felt that I understood how she must have been feeling.

We would go out shopping or out to lunch, and I always felt as if I were with one of my younger girlfriends. We talked and laughed a lot about silly things. She would stop by my office and surprise me with dim sum from Chinatown and just to say hello. She would often say that she was just out taking bus rides and shopping in Chinatown or at her favorite downtown store, the Emporium. Not long before she suffered a stroke, she called me to say that she was downtown and lost. She was trying to find my office to visit me but couldn't remember the address or the building. She had been to See's to buy me some candy and she wanted to stop by, but she was confused. I was extremely busy at work, but I talked to her and got her to describe where she was so I could go find her. I was able to locate her pretty quickly, and she calmed down and told me how much she appreciated what I had just done. I walked her to the nearest stop for the 38 Geary and watched her get on the bus that would take her home. I called her before leaving work late that afternoon and was relieved that she had made it and seemed to sound all right.

I had been divorced from her son for quite a while when this happened, but I felt that I should call him about it. He made sure that she got a medical evaluation, and over time, he would contact me to keep me updated about her medical progress.

Cheryl continued to visit her former mother-in-law at her now-empty home in the Richmond District. She would drive over either after work or on weekends several times a month. Cheryl enjoyed it that the two of them

continued to maintain an especially special bond. Cheryl laughed as she recalled a time when they had gone out of state by car to visit her former brother-in-law and his family:

It was before the divorce, and my ex-husband, my mother-in-law and I were driving from our home in New Jersey to visit my then brother-in-law and his family in South Carolina. It was winter, and there was a storm, and we were driving at night. Snow was blowing, the road was slick and everyone was driving really slowly. My ex was asleep in the back seat and my mother-in-law had never learned to drive, so I had been behind the wheel for a long time, and we were on the interstate, so there was nowhere to stop. Whenever she got nervous, which was a lot, my mother-in-law would snack on things like cookies, candy, chips or some of those yucky dried and salty Chinese things I couldn't ever get used to. That night, she was eating Cheese Puffs because being in a car in the snow at night was not something that she had ever really experienced before. She asked me if I were nervous while driving, and I told her that I was. She told me to take some Cheese Puffs, but I told her that I couldn't. I had to keep my eyes on the road and I needed both hands for driving. She asked me that if I wanted, she could feed me. At first I said "No," but the low visibility, my tiredness and the sound of her rattling bag and crunching Cheese Puffs made me change my mind. So there I was with my entire body stiff and nervous trying to steer us through darkness, snow and ice while eating Cheese Puffs being hand-fed to me by my Chinese mother-in-law.

Cheryl sometimes found the friendship with her mother-in-law burdensome after her father-in-law's passing. She felt that the older woman might have been developing a dependence on her. Her word for it was "clingy." Nonetheless, their friendship never wavered.

I was up at her house not long before my mother-in-law became seriously ill, and she took me upstairs to her bedroom. She went over to her jewelry box and came back with two jade bracelets that I had never seen before. They were the ring type that so many Chinese women wear on their wrists. One was plain, but the other was very beautifully adorned with finely worked gold bands. I would never claim to be a jade expert, but my father-in-law's past talks had provided me with a good eye for it. These, I knew, were very fine pieces. Coming from a much older Chinese woman, I also appreciated that they were very special. My mother-in-law handed them to

me and told me that she wanted me to have them. I was stunned and was hesitant to accept them. She pushed them into my hands and said, "Yes. I want you to take them because you have always been like a daughter to me. Take them." That made me get all teary.

Cheryl has since remarried and lives in the Berkeley Hills with her husband. The couple has also reconnected with her former brother-in-law and his wife, Frances. Cheryl no longer jogs because of what she calls "bum knees." She and her husband enjoy golf, bird watching and travel. Cheryl admits that, sometimes, when she happens to look across the Bay at night, she can't help but think of how she once was "almost Chinese."

CHINESE NEW YEAR

"GUNG HAY FAT CHOY!"

*I*f asked today about Chinese New Year, the baby boomer Chinatown kids would likely say that they remember it as a time of fun and family. They would also probably repeat whatever it was their parents or grandparents told them many years ago: "You have to behave." "You can't even think bad thoughts or we will not have good luck." "Help your mother get the house clean. We can't have a dirty house!" "Do this or that to honor your (deceased) aunt or uncle or grandparent." And they would remember how in Chinatown there were street carnivals at Portsmouth Square or Waverly Street, the lion dances, the New Year parade with Chinese high school marching bands and the block-long undulating dragon. They could never forget the flower buds, oranges and tangerines, incense and the two favorites of all kids: red envelopes and firecrackers. The adults could be serious about it, but the kids just wanted to have fun.

RED ENVELOPES AND CASH

Lay See!

Brandon Jew, a Chinatown restaurateur and owner of Mister Jew's, offered his version of what the Lunar New Year was all about for him as a child:

It was all about the red envelopes. For kids raised in Chinese American households the New Year celebration always seemed to revolve around those red envelopes. I just remember being so excited to collect them; I would stack them all up, count them, recount them, and just be so enthralled by the crisp dollar bills [they held].

But for me, growing up in San Francisco, the anticipation of Chinese New Year usually began a month or two earlier. That's when my kung-fu class would start preparing our routine for the parade. I spent eight years doing kung fu and every year our kung fu school would be in the parade.

It was incredibly exciting mostly because it was the only time I knew I was going to be on television. Our routine every year was similar—there was a walking portion where we would do a routine every other block.

More anxiously anticipated throughout Chinatown than Christmas: *lay see,* or good luck money for the New Year. *Photo by author.*

Then there was the main area, where the cameras were, we had special performances for that.

The kung fu stuff was fun, but the pageantry of the rest of the parade caught my eye, too—especially the drummers. Even to this day, I remember wanting to learn how to play the drums and control Nian, the mythical beast that terrorized towns until scared away by loud noises like drums and firecrackers.

Many years it would rain on the parade, but that didn't matter. Even if we got drenched during our routines, it was so much fun, with the cameras and the childhood treat of staying up late, past my bedtime. After the parade, the kung fu school would buy us all Chinese food: salt and pepper squid, walnut prawns, and more.

My most vivid food memories of Chinese New Year, however, didn't come from the parade; they come from my family celebrations.

On the night of the New Year, we would all go to my uncle's house in the Sunset. Everyone would make and bring their own specialty. My mom had her dish; my aunt had her dish. My favorite? My grandma would make tang yuan, those glutinous dumplings, sweetened and round. She would fill them with black sesame paste, and she made them every year. Part of the legend of tang yuan is that they symbolize family togetherness. We don't do that big family celebration anymore; instead my parents will host smaller hot pot dinners. Now that I'm a little older…I've come to realize how important it is…to continue cultural traditions and celebrations. I haven't been to a red egg and ginger party in so long, for example.

I got married a few months ago, so this will be the first year that I'll be giving, instead of receiving, red envelopes. I think the transition is a good metaphor for the way that a new generation must take it upon themselves to keep family and community traditions going…that's what New Year means to me.[110]

There were also the carnivals. Several, like the one in Portsmouth Square or the one on Waverly Place, were large affairs with food, games and rides. Others, like the indoor activities at the old Buddhist church just across the street from Portsmouth Square or in the basement of Old Saint Mary's on the corner of Grant and California, mainly featured games of chance. Darryl Eng remembered:

I went to all of them if I could. The rides at Portsmouth Square were more for little kids, but I would try to get on some of them anyway. I never had

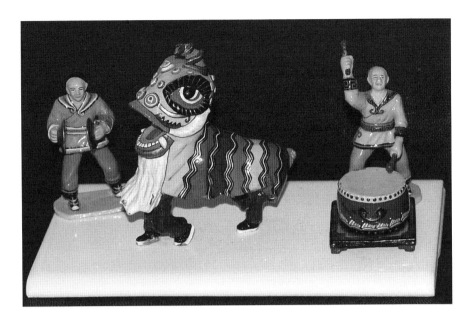

Above: Scale figures depicting the Lion Dance. Only the smoke from thousands of exploding firecrackers is missing. *Photo by author.*

Left: Boy dressed in traditional cap and clothing for Chinese New Year. Photo dated January 27, 1952. *Author's collection.*

much luck tossing things. There were games where you had to toss a dime into a dish and you would win the dish. Or you had to cover a red spot on a flat surface with a dime to win. Those game booth guys were really tight. They looked and looked at where your dime landed, and if there was just a bit of red showing, you were out of luck. They had these hoop things that were used for embroidery that you had to get completely around the thing you wanted to win, and that was almost impossible for me. I would lean as close as I could before tossing it, but the guy operating the game would always push me back. I did win a goldfish once by tossing a ping-pong ball into the little bowl with the fish in it. I felt good at first, but then I had to carry the thing around, and it was a pain. It died after a day or two.[111]

"BUY FIRECRACKER?"

"This Was One Trip to Chinatown That Did Not Involve My Mother"

Ken Sproul has an extensive blog about his beloved San Francisco in which he takes readers, chapter by chapter, through each of the city's neighborhoods. He first visited Chinatown with his mother in the 1950s and has enjoyed it so much over the years that, now a parent himself, he continues to stop by with his own children several times yearly. Sproul recalls how, as a schoolboy, he would venture into the neighborhood's narrow and dim alleyways in search of firecrackers:

The real mystery of Chinatown was to figure out how and where to buy fireworks for the Fourth of July or Chinese New Year. Wing Duck on Grant Avenue had a basement room with hidden cabinets. This was one trip to Chinatown that did not involve my mother. We took the streetcar or rode our bikes to search for rockets, double aerial bombs, M-80s, and any other forbidden fruit. Long walks down dark corridors or dank alleys following a "buy firecracker?" tout would usually lead to success. Sometimes money was given to total strangers with the promise that they would return with the right stuff. Chinatown was a great experience and certainly broadened one's horizons as to what was out there in the world.[112]

An ABC who used to live in Chinatown describes how he used to sell firecrackers.

During Chinese New Year, I sold firecrackers and other fireworks to the white kids. Chinese friends and I could buy a case of one hundred packs of sixteen firecrackers each for seven dollars at a place called Wing Duck on Grant Avenue. This was usually early in the Chinese New Year season, because the police would soon raid the store and put a quick stop to fireworks sales. We would take individual packs to school and sell them to classmates for a quarter each. We also would carry loose packs in small paper sacks—like a sack lunch—to sell to tourists in Chinatown. We only carried a few packs at a time, because if we were caught by the police, they would confiscate the firecrackers. We wouldn't lose too much that way. Some white people who lived in the city knew how things worked, and they would keep an eye out for any of us Chinese kids with our little brown sacks. We would just make eye contact, ask how many they wanted and make the deal. For true tourists, we would approach them and quietly ask if they wanted firecrackers. This was a little risky, because the prospective buyer would usually talk too loudly, ask too many questions and take too long to make a deal.

The Lion Dance, which took place during Chinese New Year, provided firecracker extravaganzas that were acceptable to the city's lawmakers. Lion Dances were often done to raise funds for one or another charitable or not-for-profit organization. In the case of raising money for the Chinese Hospital, the dance troupe, usually from one or several kung fu clubs, would go from Chinatown business to business seeking offerings. If a donation was made, the group would stop and perform to the cacophony of its own drums, cymbals and gongs amid hundreds of exploding firecrackers. In some cases, strings of firecrackers could be so long that they were hung down from the roofs of three- and four-story buildings. The performances could be heard from many blocks away as they made their way through the streets. People would just follow the sound to the site of the performance if they wanted to watch.

Harold Lee said: "I didn't like the Lion Dance when I was little. It was too noisy, and I was scared of the firecrackers. After I got older, it was fun. I sometimes walked along so that I could toss packs of firecrackers at the dancers. They were pretty cool. It never seemed to bother them. I guess they just got used to it."[113]

THE RED'S PLACE FIRECRACKER EXTRAVAGANZA

Tradition Is a Blast

Facing Jackson Street directly across from each other at the end of Beckett Alley are two of Chinatown's longtime institutions: the New Lun Ting (the Pork Chop House) and Red's Place. Regulars will swear that the pork chop with gravy dish served up at the Pork Chop House is absolutely to die for. Its near neighbor, Red's Place, a small family-run watering hole, is broadly popular for its annual firecracker display that serves to usher in the New Year. Throughout the afternoon and early evening of Chinese New Year's Eve, passersby, other nearby businesses and mobs of kids set off small batches of firecrackers all around Beckett Alley. The ground becomes covered with the red wrappers of innumerable spent firecrackers, and the air is cloudy with the lingering smoke from the most recent explosions. The pop and crack of bursting powder persists for hours.

Thirty-four-year-old Jerry Chan assumed ownership of the small bar after his parents, who had owned it since 1990, passed on. Red's has been open for somewhere close to one hundred years. There is some speculation that it originally opened as a restaurant. When he took over the business, Jerry admits that he knew nothing about how to do it. He depended on the advice, support and help of the bar's loyal regulars to learn the trade. As far as those who grew up in Chinatown in the 1950s and '60s, Red's has simply "always been there." Jerry does not remember when Red's began the tradition of the 100,000-firecracker New Year inaugural, but he feels an obligation to keep it—as well as Red's—alive. "This city is changing rapidly, and this [Red's Place] is one thing we don't want to lose….I don't like firecrackers. I've had too many bad experiences."

According to a recent newspaper report on Red's, Chan and the "Big 100":

> *When he was 9, a firecracker exploded in Chan's hand. He hasn't been wild about them ever since. But traditions are traditions, and the owner of Red's must light the "Big 100." That's just the deal.*
>
> *Chan didn't emerge onto the street until 11:50 PM….Jackson Street was* [already] *covered in an inch of debris* [from previous fireworks]*….Amid the hundreds of spectators it was the collection of* [longtime Red's clients] *who seemed to be running the show. They emerged from Beckett Alley with armful after armful of bright red boxes, all filled with a mixture*

160

Left: Red's Place, a Chinatown legacy business that hosts the annual New Year Firecracker Extravaganza. *Photo by author.*

Below: Even when it is not New Year, the Lion Dance takes place to bring blessings on new businesses. *Ken Cathcart Collection. Courtesy of Schein and Schein.*

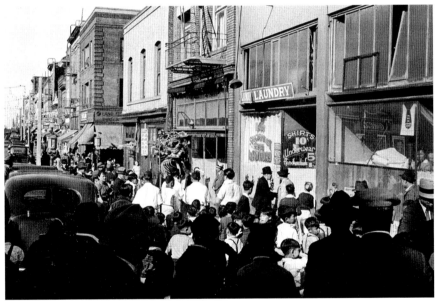

of cheerful explosives. A yellow wire had been hung across Jackson Street and revelers began to drape thousands of firecrackers from it.....No one [appeared]...to be in charge of public safety.

Chan pulled one of those long lighters from his back pocket, the kind one uses on fireplaces—he didn't want to get any closer to the pyrotechnics than he had to. Then, amid a roar of encouragement, the owner of Red's flicked the lighter and Jackson Street was illuminated in light and sound.[114]

The night was filled with rapid bursts of light that resembled camera flashes blended with lightning. At times, there was a strobe effect. Then there was a period of prolonged and searing white brightness that would be followed by the strobe effect again. Gray-white smoke billowed and swirled. It was acrid and almost hot against the nasal passages of anyone who stood nearby. The exploding firecrackers gave off deafeningly sharp and staccato snaps and cracks. Loose firecrackers flew about, fuses hissing and sparkling toward the unwary. People twisted and jumped to avoid them. A line of fire fiercely winked its way upward to touch off thousands of as-yet-unexploded firecrackers. The frenzied dance of light, sound and billowing smoke went on and on and on. The crowd was mesmerized. It slowly shuffled ever closer to the epicenter of the action. The confetti of rent and tattered firecracker detritus gently rained down on the upward-gazing faces of young and old alike. Fearsome as the display might have been, there was excitement, happiness and even rapture as the firecrackers continued to explode. Finally, the sound was reduced to intermittent pops as the last of the firecrackers went off. A thick fog hung silently for a moment. When there were no more snaps or pops, the crowd cheered and applauded amid shouts of "Gung hay fat choy…Happy New Year!"

Red's has gloriously called forth another new year to San Francisco's Chinatown.

CITY OFFICIALS, BANDS, PRETTY GIRLS AND A MIGHTY DRAGON

"It's an Honor to Carry Gum-Lung"

The grand finale to Chinatown's celebrations is always the Chinese New Year parade, which takes place on the last day of the two-week festival. Except for its very colorful Chinese costumes and decor based on centuries of myth and tradition, the parade itself is organized like all other public parades. It starts with cars carrying waving and smiling officials or dignitaries; themed floats, many bearing smiling and pretty young women; bands; lion dancers; school groups; and at the very end, the grand finale—in Chinatown's case, the block-long *Gum Lung*, or Golden Dragon.

The mayor of San Francisco is almost always among the officials riding at the head of the parade. In the late 1960s and early '70s, the mayor

was Italian American Joseph Alioto. One former Chinatown resident whose family watched the parade from their shop fire escape facing Grant Avenue recalled:

My father was a pretty quiet person. He never raised his voice or yelled. Even when we went to Giants or 49ers games, he kept his excitement and enthusiasm pretty low-key. One year, we were on the fire escape for the parade. When Alioto's car came by, my father yelled at the top of his lungs, "Mussolini! Booooo! Mussolini!" Alioto looked up, as did a couple of the cops escorting him. My mother was mortified. I didn't know what to think. Later, my father explained that he was reacting to how Italian American immigrants never suffered the type of discrimination that the Chinese did. He was bitter that the Italians had not so long ago been able to attack and beat Chinese people up in North Beach with no repercussions. Alioto represented favoritism, racism and fascism all rolled into one, according to my father.

Among the parade's other regular participants is the annual winner of the Miss Chinatown pageant. The pageant, which began in 1958, provides the winner with prizes and a scholarship in exchange for her services as a goodwill ambassador for the Chinese community. Rose Chung, a first-generation ABC and the youngest of a family of five girls, spoke about her childhood dream to become a pageant contestant:

My father passed away when I was only three, so my mother had to support and raise us by herself. She worked as a seamstress in a gai-chong and was very protective of us. She wouldn't allow us to go out, do sports or take part in any after-school activities. Even when my older sister was finally permitted to go on a date, we all had to go with her as chaperones. It got pretty expensive for the poor guy! Except for regular school and Chinese school at Saint Mary's, I never went anywhere or did anything. We lived in North Beach at Mason and Chestnut, and my sisters and I led very quiet, limited and boring lives. We just didn't ever have much of anything to do.

When I was very young, I saw a fashion show and became fascinated by the grace and beauty of the models as well as with the styles and colors of the clothes they were showing. It filled my head with dreams of a day when I might someday be like one of those models and get to wear beautiful and nice clothes like they did.

I also remember one year when I was still pretty young when I spent hours and hours and days and days just looking at the Miss Chinatown

contest poster. I just couldn't stop looking and looking at the pictures of all those beautiful women. I read and re-read all their biographies. I memorized all their names and everything that was written about them: what they did and how they did it. I did this the next year and for several years after as well. I was able to remember just about everything about all the contestants over that period of time.

I finally got to see the actual pageant when I was seventeen. It was wonderful! I was still holding on to my childhood dreams, and as I watched the contest, I was practically overwhelmed by just being in the presence of such glamour. In spite of my dreams or fantasies, I was really short on confidence about myself. My sheltered life had not prepared me to do anything so outrageous as to speak or perform in public. Over the next few years, however, I went to several more pageants. I began to catch myself mentally comparing myself to the contestants. I eventually arrived at my own conclusion that if I were actually in such a contest, I could probably be somewhere in the middle of the pack.

After graduating from college with a degree in X-ray technology, I had matured enough to start coming out of my shell a little. I thought that I should try a small pageant just to see what might happen. I thought that if I didn't bomb it, I might go on and make a real effort at fulfilling my dream of taking a shot at Miss Chinatown. So, in December of the year when I was twenty-two, I entered a pageant sponsored by the Bay Area Chinese Student Alumni Association. I didn't win, but I placed as the first runner-up. I was pretty happy about that, but I was really surprised when the association offered to sponsor me in the next Miss Chinatown contest that was coming up in February.

I hired a dance teacher to help me with the talent portion of the contest. This probably seems pretty casual, but the demands of when I took part weren't as tough as they are today. The current contestants have really high levels of education, like conducting their own research in science, and the talents they have are almost like professional level. My mother was not very helpful or supportive. I mean, she was deep inside probably proud that her daughter would be involved in such an important thing for the Chinese community, but she would say things like, "What qualifications do you really have?" or "Oh, you'll never win." Back then, I thought that she was just being the way my mother had always been. Not until later did I realize that a lot of Chinese parents are like that. They overexaggerate modesty and work very hard at being low-key and not show off. I was kind of relieved to know it. I pressed ahead anyway, and after I won, my

mother was still pretty quiet about it, but I could tell that she was pretty happy and proud about it.[115]

Rose was Miss Chinatown 1981. She says that despite her role as "goodwill ambassador" for the Chinese community, there were no truly demanding or rigorous events that she had to take part in. She recalls a lot of photo ops, grand openings and appearances at social functions. One of her strongest memories of the time came as she rode in the New Year parade. She recalls standing and waving down at the onlookers and seeing the smiling faces of many young girls who reminded her of herself not that long ago. She became determined to do whatever she could in the future to serve as an inspiration to young people. She also felt that because of her sheltered childhood she wanted to "participate in community activities."

Rose founded the Miss Asian America Pageant in 1985. It has grown from a humble local event to an internationally recognized one with regional competitions nationwide. Contestants have worked for hundreds of nationwide and regional charitable organizations. Rose is also currently president of the Miss Asian Global Pageant and on the board of directors of Asian Perinatal Advocates and the San Francisco Coalition of Asian American Government Employees. Rose also serves on the board of the California Chinese American Republican Association and the Chinatown Neighborhood Center.[116]

One of Chinatown's most iconic marching groups was the Saint Mary's all-girl Drum and Bell Corps. The bells were glockenspiels, which the girls were able to play expertly only after long hours of Saturday morning practices. The group featured brightly embroidered gold-and-red traditional Chinese garb modeled after costumes used by the Peking Opera. The costumes included an impressive headpiece complete with tassels hanging from its sides. The group started just prior to the outbreak of World War II and gained considerable fame in 1961 when it was invited to march in President John F. Kennedy's inauguration parade. Despite the corps' very Chinese appearance, its musical repertoire was completely Western. In addition to marches, show tunes and compositions taken from popular music, the play list always included "San Francisco," "California, Here I Come," "Chinatown, My Chinatown" and their namesake piece made famous by Bing Crosby in the movie *The Bells of Saint Mary's*. The school resided on Stockton Street for decades but was forced to move after the 1989 earthquake made the building unsafe. The school was reestablished by the Archdiocese of San Francisco in the new International Hotel Building on

Power, strength and fortune: the dragon on the site of the former Empress of China restaurant. *Photo by author.*

Kearny Street in 2005. Unfortunately, declining enrollments finally forced the school to close.

The undulating and nearly 250-foot-long Golden Dragon, *Gum Lung*, comes at the very end of the parade. The dragon is lit by hundreds of incandescent bulbs that give it a radiant and golden glow. Unlike the dancing lions that make appearances for special occasions throughout the year, *Gum Lung* only comes out for the New Year parade.

The dragons used in the parades have all been fabricated overseas by experienced master craftsmen. The body frames are bamboo, and the skin

is made from painted and embroidered gold cloth. The lights are powered by a portable generator that trails behind the dragon. The dragon is carried by members of martial-arts societies who hold him up with long poles. Gary Low, a veteran of many parades with Gum Lung, said: "It's two and a half to three hours of constant moving—moving fast, running around, moving slow and having firecrackers going off all around you. You have to have good cardio and stamina. It's an honor to carry Gum-Lung because it is one-of-a-kind. It's an ancient tradition [to make the dragon]. There's probably [only] two or three masters that make the dragons from scratch. A lot of them have died and did not pass on their art."[117]

9

ON GROWING UP AS A
SECOND-GENERATION ABC

"I ENJOYED BEING DIFFERENT AND UNIQUE"

Allison Wong is a second-generation ABC. She was born in 1986 and has lived her entire life in Louisville, Kentucky. Allison has visited Chinatown in San Francisco and has been to China with her father. She has also been to the Chinatowns in Washington, D.C., Los Angeles, Chicago and New York City. She and her father, a first-generation ABC and former Chinatown kid, recalled a recent conversation they shared.

Allison remarked on her childhood: "I do not think that having a Chinese background caused me to think or behave in any particular way. I feel that I grew up white. There were always a few other Asian or part-Asian kids at school, but I didn't look at them or at myself differently. I was never treated or reacted to differently, so I considered myself white, and that was what was normal for me."[118]

Allison's father laughed a little and said: "As hard as my parents and extended family tried, I'm not so sure I didn't grow up white as well. That was especially true once I started school. The school system had a set curriculum that was oriented to mainstream American values and culture. We learned it and we became it. I can't speak for all Chinatown kids my age, but my friends, cousins and I all became, to one degree or another, 'bananas': yellow on the outside and white on the inside."

Allison continued:

In high school, I enjoyed looking different from most of the other students. I enjoyed being different and unique. I had learned about certain aspects of

Chinese culture, so I could talk to my friends and classmates about them. It was things like dim sum and Chinese New Year. I could write a few words in Chinese, and my friends thought it was cool that I could write my name, "Wong," in its Chinese character. People would sometimes react to my name. Knowing that it is not an American surname, they would be a little perplexed on first meeting me. People ask me where I am from, and when I say, "Louisville, Kentucky," they sometimes give me a little look, but they aren't really bothered by that, and I am not bothered that they asked. I could always tell that their reaction was just one of curiosity. There was never any negative reaction to me. I would tell people the facts about myself: I was half Chinese, my father was Chinese but born in San Francisco, all four of his grandparents were from China and my mother was white and from Kentucky.

My appearance is the most Chinese thing about me, and I understand and accept that fully. Like I said, I am as mainstream American as I could be, but I still enjoy identifying myself as Chinese or as part Chinese. If I am in the presence of something Chinese, like an art exhibit, for example, I tend to feel a sort of ancestral connection to it even if it is only in my subconscious mind. Even though I don't speak Chinese and I really don't know about the culture intimately or in-depth, I am at least somewhat familiar with a lot of things that are Chinese. I don't think that I would go out and immerse myself in studying about China or its culture, but over time, whenever it might be, I would be interested in learning more. Writing would be fun; speaking, I don't know. I had such an awful time trying to speak Mandarin, I don't know if I could ever do it.

TEACHING ENGLISH IN CHINA

"I Learned More About Some Things That Were Familiar"

In 2005, after her freshman year of college, Allison went on a five-week assignment to teach English in China. Louisville's Chinese culture and history center, Crane House, sponsored an annual "Teaching in Asia" program for which her father had decided to volunteer. Crane House was founded in 1987 by Helen Lang, an ABC who grew up in Washington State, near Seattle. She and her husband, a physician, had found their way to Louisville, and Helen wound up dedicating herself to creating Crane House.

With the program's permission, Allison's father asked if she wanted to participate as an assistant teacher to the group of four Louisville teachers to which he was assigned. She agreed and ended up at the Language School at Jiujiang, China, where she wound up helping to teach conversational English to several classes of adults and several other classes of grade-school students.

Of that experience, Allison said:

> *When my dad asked if I wanted to go to China for the Crane House program, I said yes right away. I mean, I love to travel, and it presented a really great opportunity to me. I always thought that I should go to China because of my Chinese heritage, and the Teaching in Asia program just made it so easy. How could I not go?*
>
> *I went with no real expectations of anything. There was the adventure of travel, of course, and I was a little nervous about the teaching part. It helped that I was going as an assistant, though. I knew that there would always be someone with lots of experience right next to me. After I met everyone in our group at one of the organizational meetings, I saw how nice everyone was and I relaxed a lot more. Once the real teaching began, I found that our students, both the young ones and the adults, were just like students anywhere. I sometimes lost track of the facts that they were Chinese and that I was in China!*

Allison's father said: "I wanted to make up for never really teaching Allison about her background. The trouble was, I never thought that I knew enough about it myself. The owner of a Chinese restaurant in Louisville once asked if I didn't want to sign Allison up for Saturday Chinese lessons that her kids and those from several other families were taking. I thought, 'Chinese school! Good God! No!' When the Crane House program came up, I figured that Allison and I could both learn a thing or two. I myself wasn't feeling all that much more Chinese than Allison was."

Allison discussed some of her thoughts and feelings about being in Jiujiang:

> *I was a little surprised by the way things were in China. I thought things were a little "third-worldly." Even though Jiujiang has more than four million people, it isn't one of China's major cities. It was more crowded and polluted than I thought it would be, but after staying a few days in Beijing I sort of understood. Walking around, I thought there was a funny smell in the air, but then I thought back to San Francisco, Chinatown,*

Allison Wong with students while teaching English in Jiujiang, China, in 2005. *Courtesy of Allison Wong Hooker.*

Allison Wong leading a part of the Crane House Teaching in Asia closing ceremony, Jiujiang, China, 2005. *Courtesy of Allison Wong Hooker.*

The old Chinatown telephone exchange building, where bilingual operators provided community directory assistance. *Photo by author.*

and I remembered that things smelled different there, too. It wasn't a bad smell; just different. The smells from the markets and of people's cooking were pretty noticeable, but then I just figured that was the way it normally was. There were also the sounds of the language. Everyone was speaking Chinese, as were the voices from radios or TVs that I could hear walking around. All in all, I don't think anything surprised me too much. My dad said that walking around Jiujiang really brought him back to his Chinatown days.

One notable thing was that there was a lot of pushing and shoving when we were in a crowd, and that was pretty often. I got used to it and got to where I would just push back. I wasn't mean or aggressive, but I was firm. I didn't like it, but I could do it. Even that was a little familiar. I remember taking the number 30 Stockton Street bus through Chinatown, and boy, some of those older Chinese ladies could really get around pretty well.

Allison's father added: "That 30 Stockton bus would toughen anyone up. I rode it and its equally rough-and-tumble counterpart, the 15 Kearny, for the better part of twenty years. One thing I will say in favor of old Chinese ladies, though, is that they don't have all that much on the Galileo High School students of my day. The way we charged onto those buses, through front door and back, was pretty wild."

COMPARING CHILDHOOD CULTURES

"It Would Have Been Cool to Grow Up in Chinatown"

Allison talked a little about her San Francisco Chinatown experiences, and she speculated on what it could have been like for her to grow up there, as her father had:

When I visited Chinatown, I was with my dad, so I was very comfortable. It was also comforting to know that, however differently things may have looked, smelled or sounded, I was really just in the USA. Sure, there was a lot of Chinese being spoken, but there was just as much English. I also took into account my physical appearance. I looked the part, and I was happy to think that I "fit in." I looked and felt like a native, and I felt like I belonged there.

When I was in middle school, our church youth group took a trip to New York City. We wound up in Chinatown, and our adult leaders trusted us enough to let us go around independently so long as we did so in small groups. I felt like I did in San Francisco: I "fit in." What some of the others who were with me might have found strange or even shocking was just normal to me. I think that some of my companions were pretty taken aback by seeing things like roasted ducks hanging behind steamy and grease-splattered windows.

I had a lot of fun showing one of my good friends what I knew about Chinese life and culture. She wasn't exactly a stranger to different cultures, though. We met and became friends in the third grade after she came to Louisville from England. Still, it was cool to me to be able to explain a little about the language, the smells, the sounds, the small and cramped nature of shops, the food and the general look and feel of things. There were shops with some really junky and tacky souvenir stuff alongside of other places that sold really nice and expensive antiques. To me, New York's Chinatown wasn't that different from the one in San Francisco.

Whole roasted ducks were once banned from window displays for "health reasons." Chinatown merchants protested on cultural grounds. *Photo by author.*

Ross Alley is a tight-fitting commercial and residential street. This was an early twentieth-century site of gambling dens and houses of prostitution. *Photo by author.*

I have thought about what it might be like to have lived in Chinatown as a child. I wouldn't like it now, of course. It just seems too crowded. Apartments and other types of living spaces are jammed together, and there is a hustle and bustle that I am not used to. In my childhood neighborhood in Louisville, there is plenty of space between houses, big yards, trees and wide and quiet streets. I was friends with the neighbor kids, and we were just one or two houses apart. We played in our yards or on the sidewalks, but if we really wanted to do something, we needed a parent to drive us. We couldn't just walk some place for a snack, a movie or an activity like youth group, dance or sports.

Although I hate crowdedness—it's just a personal thing with me—I can see where it would have been fun to grow up like my father did in a close neighborhood. I think it would be cool to live super close to my

friends. My dad said that when he was growing up he could look into the neighbor's kitchen from his balcony and talk to the kids who lived there and who were his friends. He also said that he could walk up to the roof and another friend's mother would sometimes toss Chinese candies to him from her window.

I could have had so much fun if my good friend Alix and I had lived like that. We would never have to get anyone to drive us anywhere. If we wanted to see a movie, there were a bunch of theaters that we could walk to. We wouldn't even need bikes. The old Chinese Recreation Center in Chinatown was where my dad and his friends played basketball, volleyball and dodgeball.[119] Alix and I loved volleyball when we were in middle school. What fun it would have been to just walk to the center for volleyball! My dad took me to Eastern Bakery once, and I went in by myself to buy a cha-siu bow—the baked kind—for a snack. We didn't do that in Louisville. We had to go through a drive-in window with a parent or we would have to go and sit down at a table and order a meal. It would be pretty weird to walk down a street in Louisville while eating something. I think that I would have really enjoyed living my kid years like that. My

Interior view of Eastern Bakery, where a young Allison Wong experienced her first baked cha-siu bow. *Photo by author.*

Right: Chinese Recreation Center, renamed for Betty Ann Ong, a Chinatown kid who rose above all with strength, dignity and bravery. Chinatown will remember her. *Courtesy of Charlie Wambeke and Melody.*

Below: Chinatown gate at Bush Street and Grant Avenue. Chinatown is ahead, downtown is behind and the Financial District is to the right. *Photo by author.*

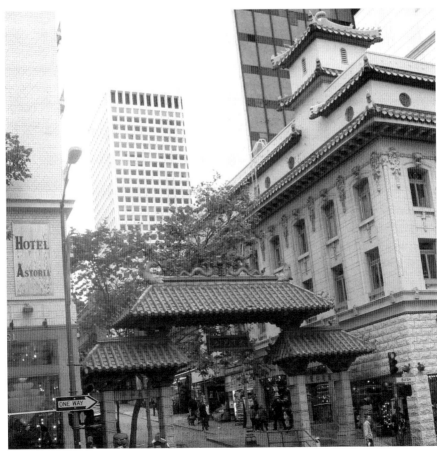

friends and I would have had so much freedom to just go anywhere in Chinatown, where things are close and safe. That kind of childhood would have been so enriching for me as a kid.

My mother recently told me that she no longer has any very close friends from her childhood like my father still does. She did, of course, have friends, but she couldn't just get with her classmates and hang around any time they felt like it. She grew up in a small town, but still, the kids she knew lived far apart enough that they didn't see each other much outside of school. She thinks that my father was able to form really long-lasting friendships because he and the other kids that he grew up with lived so close to one another. That kind of close living probably helped kids be more like brothers and sisters than just friends. They didn't have to rely on adult assistance as much as we did in Louisville, so I can see how my dad and his friends counted on one another a lot as they were growing up. They could teach and learn things from each other. Those Chinatown kids very likely bonded in ways that my mother and I could not with the people we knew growing up. Even living as far away from San Francisco as Kentucky, my father still visits with people he knew from when he was in kindergarten or the first grade. Whenever he goes back to California, he is sure to get together with people he knew in junior high and high school, too.

Knowing what I know, I am glad that I grew up the way I did in Kentucky. But Chinatown, San Francisco, could have been pretty cool, too.

NOTES

Chapter One

1. *A Moment in Time*, directed by Ruby Yang.
2. Moyers, *Becoming American: The Chinese Experience*, Part 3, "No Turning Back."
3. Yang, *A Moment in Time*.
4. Ibid.
5. Norman Fong, in Chin, "Growing Up in San Francisco Chinatown in the 1950s."
6. Ibid.
7. Ibid.
8. Although this particular martial-arts form is usually spelled "kung fu," many speakers of southern Chinese dialects pronounce it with the "G" sound.
9. Fong, "Growing Up."
10. Yang, *A Moment in Time*.
11. Ibid.
12. The films were sent overseas from Taiwan and Hong Kong with Chinese subtitles for the benefit of viewers who spoke neither Mandarin nor Cantonese, the usual languages in which the films were originally made. English subtitles were also included, and some Chinatown kids would even use the films as a resource for language learning or practice.
13. Yang, *A Moment in Time*.

14. Ibid.

15. Irene Dea Collier, conversations with author, 2016 and 2017.

16. Ibid.

17. *On Strike!: The Birth of the College of Ethnic Studies*, San Francisco State University Archive.

18. Ibid.

19. Before cable television, the local San Francisco channels and their network affiliates were as follows: KTVU Channel 2 (independent), KRON Channel 4 (NBC), KPIX Channel 5 (CBS), KGO Channel 7 (ABC) and KQED Channel 9 (PBS).

20. *On Strike!*

21. Mark Zannini, written communication to author, 2017.

22. Norman Fong, conversation with author, 2017.

23. Fong, "Growing Up."

24. Ibid.

25. Chuck, *Chinatown: More Stories of Life and Faith*, 114.

26. Yang, *A Moment in Time.*

Chapter Two

27. Wong Fei Hung was a real person who lived in the late nineteenth and early twentieth centuries. He was a physician and kung fu master who became a folk hero. More than one hundred films have been made about him. While Kwan Tak Hing was featured in practically all of the Wong Fei Hung films from the 1940s through the 1960s, current actors, including the likes of Jackie Chan and Jet Li, continue to star in films about him.

28. Sherman Wong, conversations with author, 2016.

29. Judy Wing Lee, written communications to author, 2016.

30. Hoover Ng, comment on the topic of "Chinatown Movie Theaters," in "We Grew Up in San Francisco Chinatown," Facebook, September 2016, https://www.facebook.com/groups/wguisfct.

31. Walden Jay, "Chinatown Movie Theaters."

32. Mark Zannini, conversations with author, 2017.

33. Melody Chan Doss-Wambeke, written communications to author, 2016 and 2017.

34. Yang, *A Moment in Time.*

35. Ibid.

36. Ibid.

37. Ibid.
38. Ibid.
39. Darryl Eng is the pseudonym assigned to an interviewee who prefers that his real name not be used in this book. The facts and quotes attributed to the name reflect the thoughts and experiences of the contributing interviewee, and they do not represent those of anyone who actually is or was named Darryl Eng. Darryl appears in several chapters, and all of his anecdotes and stories were communicated to the author via conversations or written communications.
40. Ibid.
41. Jay, "Chinatown Movie Theaters."

Chapter Three

42. Darryl Eng. The names "Uncle Frank" and "Aunt Susan" used in this chapter were changed from their originals in order to safeguard Darryl's anonymity. They are not meant to represent anyone else's Aunt Susan or Uncle Frank, living or deceased.
43. More than a few ABCs found this to be true. They often did poorly in Chinese school, generally disliked it and speak of it today with words like "awful," "a waste of time" or "torture."

Chapter Four

44. A poster for the 1973 film shows an actor with a club resembling a cross between a two-by-four and a baseball bat.
45. Walden Jay, comment on the topic of "Corporal Punishment," in "We Grew Up in San Francisco Chinatown," Facebook, October 26–28, 2016, https://www.facebook.com/groups/wguisfct.
46. Gary Kong, "Corporal Punishment."
47. Mel Lim, "Corporal Punishment."
48. Dabin Lo, "Corporal Punishment."
49. Cooper Chow, "Corporal Punishment."
50. Jae Jee, "Corporal Punishment."
51. Susi Ming, "Corporal Punishment."
52. Jay, "Corporal Punishment."
53. Wanda Wong, "Corporal Punishment."

54. Lio, "Example of 'User Innovation' from Chinese Mothers."
55. Robert Lowe, "Corporal Punishment."
56. Michael Tam, "Corporal Punishment."
57. Kong, "Corporal Punishment."
58. Jay, "Corporal Punishment."
59. Chuck, ed., *Chinatown: Memories of Life and Faith*, 78–79.
60. Ibid.
61. Lowe, "Corporal Punishment."
62. Ibid.
63. Ibid.
64. Conant and Hammond, "In Their Words: How Children Are Affected by Gender Issues," 35.

Chapter Five

65. Raymond Lee, comment on the topic of "Working in a Family Business," in "We Grew Up in San Francisco Chinatown," Facebook, September 30, 2016, https://www.facebook.com/groups/wguisfct.
66. Ibid.
67. Ibid.
68. The term is used here to say that Michael's father was a longtime, established expert in his field: jewelry. Many of Chinatown's shops, as mentioned by Raymond Lee, sold inexpensive trinkets and novelty items to tourists. Michael's reference to his father as "OG" can be considered a deep compliment to his father's professional expertise and dedication to both his work and his family.
69. After the mid-1970s fall of Vietnam, there was another influx of Asian immigrants into the United States. Some of the newcomers were ethnic Chinese or Chinese Vietnamese whose familiarity with the language and general culture led them to Chinatown, where they, like the post–World War II southern Chinese before them, made homes and/or established small businesses.
70. Michael Tam, "Working in a Family Business."
71. Darryl Eng, conversations with author, 2016 and 2017.
72. Leland Wong, "Working in a Family Business."
73. Ibid.
74. Ibid.
75. Herb Caen wrote a daily column for the *San Francisco Chronicle*. His pieces dealt with local goings-on, insider gossip, the social scene and political

happenings. He was a master of the pun, and his columns were always cheerful and humorous. Caen's writings also reflected his deep love for his city and its citizens.

76. Wong, "Working in a Family Business."
77. Chuck, *Chinatown: More Stories of Life and Faith*, 133–34.

Chapter Six

78. Melody Chan Doss-Wambeke, comment on the topic of "Favorite and Least Favorite Chinese Foods While Growing Up" (hereafter "Foods"), in "Ed Wong," Facebook, January 3–4, 2017, https://www.facebook.com/ed.wong.52438.
79. Jack Woo, "Foods."
80. Dale Filipas, "Foods."
81. Nanette Lim, "Foods."
82. Marilyn King, "Foods."
83. Herman Jew, "Foods."
84. Darryl Eng, conversation with author, 2017.
85. JuJu Lee, "Foods."
86. Irene Dea Collier, conversation with author, 2017.
87. Sophia Wong, "Foods."
88. Bhide, "Lucky Foods: Jai (Vegetarian Buddha's Delight) from China."
89. Doss-Wambeke, "Foods."
90. Norman Fong, conversation with author, 2017.
91. Sproul, "Growing Up in San Francisco Memories."
92. Lee, "Foods."
93. Orange pie has been often mentioned as an "all-time favorite" by boomer ABCs. It was also available from Uncle's Café on Waverly Street. Much debate lingers over which restaurant had the best. The pie was only made by Sun Wah Kue and Uncle's.
94. Leland Wong, "Foods."
95. King, "Foods."
96. Lee, "Foods."
97. Arthur Dong, "Foods."
98. Heidi Chiao, "Foods."
99. Young, in Cynthia Tom, "Chinatown Childhood Memory Shop—Call for Memories."

100. Center for Asian American Media (hereafter CAAM), "Chef Brandon Jew of 'Mister Jiu's' Shares His Inspiration."
101. Ibid.
102. Cooper Chow, "Foods."
103. Annie Leong Lum, "Foods."
104. CAAM.
105. P.J. Leong, "Foods."
106. As told to author by Darryl Eng.

Chapter Seven

107. Frances Mathewson-Leong is a pseudonym, and the experiences attributed to her in this book do not reflect those of any person, living or deceased, who was ever named Frances Mathewson or Frances Mathewson-Leong. The names Mr. Leong, Mrs. Leong, Glenn Leong and Dennis Woo were utilized solely to maintain Frances's anonymity and do not represent any person, living or deceased, who has ever been similarly named. All of Frances's anecdotes were told to the author in conversations.
108. Him, Lim and Yung, *Island: Poetry and History of Chinese Immigrants on Angel Island 1910–1940*, 112–13.
109. While Cheryl is her real name, she prefers not to reveal her current surname. All of Cheryl's anecdotes were told to the author either by conversation or written communications.

Chapter Eight

110. Brandon Jew, "A Chef's Childhood Memories of Chinese New Year in San Francisco," Sfchronicle.com, February 11, 2016.
111. Darryl Eng, conversation with author, 2017.
112. Sproul, "Growing Up in San Francisco Memories."
113. Harold Lee is a pseudonym. His anecdotes and experiences in this book are not meant to represent those of any other person, living or dead, who has ever borne the name Harold Lee. Conversation with author.
114. Spotswood, "Tradition Is a Blast at *Cheers* of Chinatown."
115. Rose Chung, conversation with author, 2017.

116. Miss Asian Global & Miss Asian America Pageant, accessed February 2017, http://missasianamerica.com.
117. Kwong, "Chinese New Year: Watch Gum Long Rule Streets of SF."

Chapter Nine

118. All of Allison Wong's anecdotes were told in conversations with the author, 2017.
119. The old Chinatown Recreation Center has given way to a thoroughly modern replacement on its original site. In 2011, the center was renamed in honor of Betty Ann Ong, a typical Chinatown kid who grew up to be a very special and exceptional adult. She was a flight attendant aboard American Airlines Flight 11 on 9/11. She calmly, professionally and bravely made ground contact to give a detailed commentary of events aboard the plane as they took place. Her phone call ended when the aircraft hit the World Trade Center.

BIBLIOGRAPHY

Bhide, Monica. "Lucky Foods: Jai (Vegetarian Buddha's Delight) from China." July 2013. blog.cookingchanneltv.com/2013/07/05/lucky-foods-jai-vegetarian-buddhas-delight-from-china.

Center for Asian American Media (CAAM). "Chef Brandon Jew of 'Mister Jiu's' Shares His Inspirations and Creative Process." http://caamedia. org/blog/2013/03/02.

Chin, Steven. "Growing Up in San Francisco Chinatown in the 1950s." March 31, 2010. www.youtube.com/watch?v=8vxfvRolx3g. Accessed March 2017.

Chuck, James, ed. *Chinatown: More Stories of Life and Faith.* San Francisco: First Chinese Baptist Church, 2008.

Conant, Eve, and Robin Hammond. "In Their Words: How Children Are Affected by Gender Issues." *National Geographic* (January 2017).

Kwong, Jessica. "Chinese New Year: Watch Gum Long Rule Streets of SF." March 1, 2015. http://www.sfexaminer.com/chinese-new-year-watch-gum-long-rule-streets-of-s-f.

Lai, Him Mark, Genny Lim and Judy Yung. *Island*: *Poetry and History of Chinese Immigrants on Angel Island 1910–1940.* San Francisco: HOC DOI (History of Chinese Detained on Island), 1980.

Lio, Frank. "Example of 'User Innovation' from Chinese Mothers." April 2013. http://www.Franklio.weebly.com/blog/example-of-user-innovation-from-chinese-mothers.

Lucchesi, Paolo. "A Chef's Childhood Memories of Chinese New Year in San Francisco." February 11, 2016. www.sfchronicle.com/restaurants/article/a-chefs-childhood-memories-of-chinese-new-year-in-san-francisco-6824754.php.

Moyers, Bill. *Becoming American: The Chinese Experience.* Part 3, "No Turning Back." PBS Television, 2003.

On Strike!: The Birth of the College of Ethnic Studies. San Francisco State University Archive. Accessed March 2017. https://www.youtube.com/watch?v=c8zJqn9s0wI.

Spotswood, Beth. "Tradition Is a Blast at *Cheers* of Chinatown." www.sfchronicle.com/entertainment/article/New-Year-s-tradition-a-blast-at Cheers-of-10900781.php.

Sproul, Ken. "Growing Up in San Francisco Memories: Boyhood Recollections from the 1940s and 1950s." 2010. www.sfgenaology.com/sf/history/hgsproul.htm.

Yang, Ruby, dir. *A Moment in Time.* K. Bik Films. San Francisco: Center for Asian American Media, 2009.

Young, Andy. Tiki Central Forums. http://www.tikiroom.com/tikicentral/bb/viewtopic.php?topic=16072&forum=5&10. In Cynthia Tom. "Chinatown Childhood Memory Shop—Call for Memories." May 30, 2010. http://cynthiatom.blogspot.com/2010/05.

INDEX

ABOUT THE AUTHOR

*E*d was born at San Francisco's Chinese Hospital in 1948 and is a graduate of that city's Galileo High School. He used graduate degrees in Spanish and international relations to enjoy a long career in foreign-language education. Since retiring in 2013, Ed has been busy with his lifelong passion of writing. In addition to *Growing Up in San Francisco's Chinatown: Boomer Memories from Noodle Rolls to Apple Pie*, another of Ed's books, *The Sea Takes No Prisoners: The Men and Ships of the Royal Navy in the Second World War*, was released in England in 2018. Ed is planning a companion book as well as a memoir based on his worldwide travels in the company of his wife of forty years, Elizabeth. Ed and Elizabeth live in Louisville, Kentucky.

Visit us at
www.historypress.net
···

ML 6/2018